CHISLEHURST

THROUGH TIME

The Chislehurst Society

AMBERLEY PUBLISHING

Acknowledgements

Thanks go to Tony Allen, Chair of The Chislehurst Society; Bromley Local Studies; Rob Carling, Coopers Technology College; Michael Cooling; George Culley; Mavis Drage; Owen Dwelly; Peter Edwards; Courtney Freese, Headteacher at Mead Road Infant School; Joanna Friel; David Harding of Chislehurst Rotary Club; Jonathon Harvie, Head Keeper of Chislehurst Commons; Roy Hopper; Norland College; Michael Owen, Tower Captain at Church of the Annunciation; John Paddington, Head Teacher at St Nicholas Church of England Primary School; John Porter; Peter Ribbons; Jo Rogers; Christopher Scott at Christ Church; Alison Stammers; Helen Edith Stephenson for her wonderful Bonfire Night pictures; John Stiles of ODAS; Father George Webster of St Patrick's RC church and Mary Wheeler. Without a doubt, thanks are also due to the inestimable Don Drage and Maureen and Roger Johnson for bacon sandwiches, coffee and the patience of saints.

The Chislehurst Society website can be found at www.chislehurst-society.org.uk.

First published 2013

Amberley Publishing
The Hill, Stroud, Gloucestershire, GL5 4EP
www.amberley-books.com

Copyright © The Chislehurst Society, 2013

The right of The Chislehurst Society to be identified as the Author of this work has been asserted in accordance with the Copyrights, Designs and Patents Act 1988.

ISBN 978 1 4456 1839 5 (print)
ISBN 978 1 4456 1846 3 (ebook)

British Library Cataloguing in Publication Data.
A catalogue record for this book is available from the British Library.

Typesetting by Amberley Publishing.
Printed in Great Britain.

Introduction

Chislehurst in Kent retains a village atmosphere, despite being a suburban development in the London Borough of Bromley. The name literally means a stony place in the woods. These woods are very much apparent today, surrounded as we are by National Trust woodland, Scadbury Park and our unique central feature, Chislehurst Commons, which is conserved as open space in perpetuity by Acts of Parliament.

Chislehurst was a royal manor held by the wealthy Walsingham family. Francis Walsingham was born in Chislehurst in 1530. He went into voluntary exile in Europe when the Catholic Queen Mary was on the throne, where he met many important people and gained a good understanding of foreign politics and languages.

Sir Francis Walsingham returned to England to become Principal Secretary to Queen Elizabeth I in 1573 and as such became Queen Elizabeth's chief spymaster. Working with Lord Burghley, he devised an intricate spy network during the latter years of Queen Elizabeth's reign and succeeded in uncovering the Babington Plot of 1586 to overthrow the Queen, return England to Catholicism and place Mary, Queen of Scots, on the throne. Sir Francis died on 6 April 1590 at Chislehurst.

Sir Thomas Walsingham was visited by Queen Elizabeth in 1597 and knighted; the village sign commemorates that visit. Sir Thomas was a friend and patron of Christopher Marlowe, the poet and playwright.

Frognal Estate on the northern boundary of Scadbury was home to successive Lords of the Manor; Thomas Townshend, 1st Lord Sydney, was the first of his family to live there. He was appointed Home Secretary under William Pitt and as such was responsible for the plans to send convicts to Botany Bay in Australia. The cities of Sydney, Australia, and Sydney, Nova Scotia, are both named after this illustrious resident of Chislehurst.

Significant change came to the village with the arrival of the railway in 1865. This sparked the beginning of a housing boom and the village became home to wealthy East India merchants, lawyers and bankers. Entrepreneurs Nathaniel Strode and George Wythes set about developing estates for the newly affluent middle classes.

But a new-found fame came with the arrival of the exiled French Imperial family, Louis Napoleon III, Empress Eugenie and their son, The Prince Imperial, in 1871. They lived at Camden Place, the former home of antiquarian William Camden. The Emperor died here a

mere eighteen months after his arrival but the Imperial legacy lasts to this day, with road names in their memory, telephone numbers that reflect the IMP/467 Imperial Exchange, monuments and stone eagles aloft on the chapel of St Mary's church, where father and son were initially laid to rest. Queen Victoria had been a visitor to the Imperial family and the quiet village of Chislehurst was momentarily the centre of European attention at the funeral of the Emperor, and that of his son some eight years later.

Great mansions were built as the area became popular following the Imperial legacy, and many well-known architects, E. J. May, Ernest Newton, Aston Webb and George Somers Leigh Clarke, left trademark houses among our built environment, many of which are now in the Chislehurst Conservation Area.

More recent times have seen other characters emerge: the instigator of British Summer Time, William Willett, lived on the edge of Camden Park; Sir Malcolm Campbell, one-time holder of the land speed record, was born and is buried here; and Richmal Crompton, author of the *Just William* books, died here.

Chislehurst Caves, where many thousands of Londoners sheltered during the Blitz of the Second World War, are a tourist attraction today, but once attracted the likes of the BBC to film *Doctor Who* and David Bowie, who played a gig down there.

Chislehurst has seen change and development across the generations, nothing more so than the demolition of the landmark water tower that stretched across the brow of Summer Hill, marking the gateway to the village. However, overall, Chislehurst remains a special place of distinctive character where busy commuters enjoy the charms of the Kent countryside. It is indeed 'no ordinary suburb'.

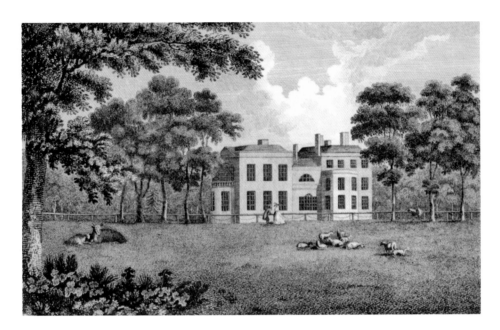

Camden Place

William Camden, the great antiquarian and historian lived in the original house on this site until his death in 1623. In the 1700s, Robert Weston was the first to call it Camden Place. Charles Pratt, a lawyer and politician, who later became Lord Chancellor, built the centre of the existing house. Pratt was created Earl Camden in 1794, adopting the name of his home. The London Borough of Camden has developed from estates owned by Earl Camden.

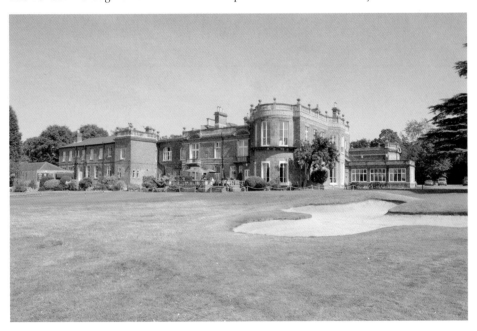

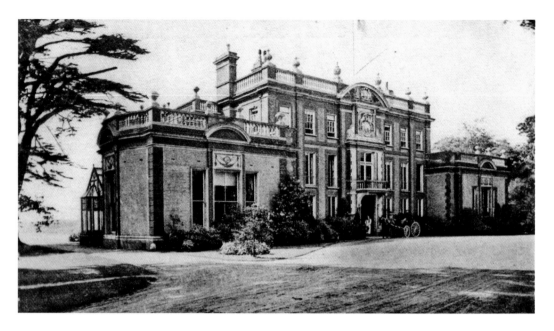

Front of Camden Place

Nathaniel Strode bought the Camden Park Estate in 1860 and made alterations in the style of a French chateau that can be seen to this day. Strode leased his home to the exiled Emperor Napoleon III of France and his family. Camden Place is possibly most famous for being the location of the death of the Emperor in 1873. William Willett, the proponent of Daylight Saving Time, bought the estate in 1890 and prepared to develop it for housing. Stopped in his tracks by the dedicated work of local residents, led by Alexander Travers Hawes, Camden Park was saved from development and is now the Chislehurst Golf Club.

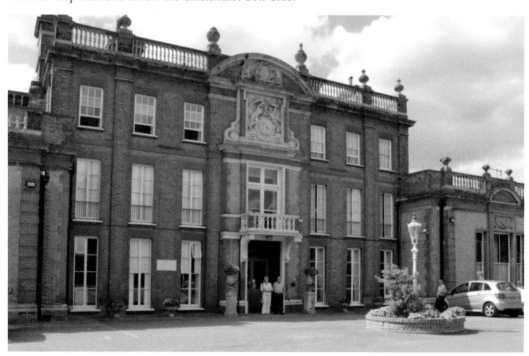

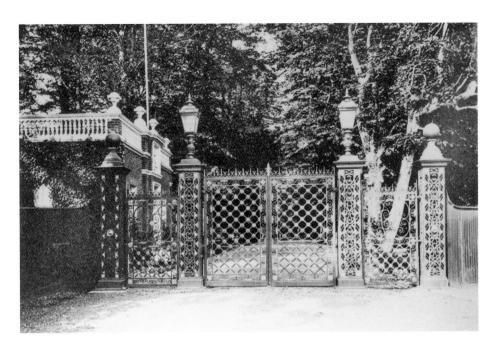

Camden Place Gates, *c.* 1880

In order to gain access to his new development in Camden Park Road, William Willett pulled down the lodge of Camden Place, moved back the ornamental gates and dedicated the land in front to the Chislehurst Commons. Grand balls were held during 'Cricket Week' at Camden Place, with carriages crunching up the gravel drive through the famous gates that Nathaniel Strode had purchased from the Paris Exposition in 1867. Wrought iron, with lamps illuminating the gold crowns above, the gates were apparently taken for the war effort in 1940 and replaced with the white pillars that you can see today. The avenue of limes that line the drive are now witness to golfers and wedding parties.

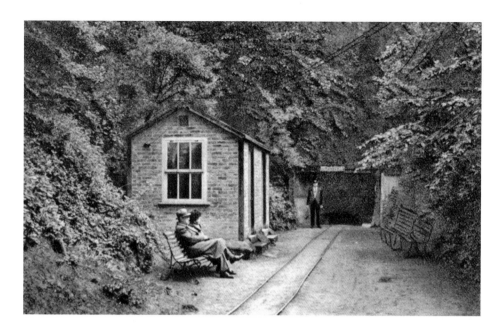

Chislehurst Caves

These ancient chalk and flint mines were mainly worked in the late eighteenth century. During the First World War, they were used as an ammunition depot associated with the Royal Arsenal at Woolwich, and in the 1930s they were used for mushroom cultivation. During the Blitz, thousands of Londoners sheltered in the caves on a nightly basis; the caves became an underground city with electric lighting, a chapel and a hospital. In the 1960s, the caves were used as a music venue. Bowie, Status Quo, Jimi Hendrix, The Rolling Stones and Pink Floyd are all believed to have performed there. The caves have appeared in several television programmes, including a 1972 episode of *Doctor Who,* 'The Mutants'.

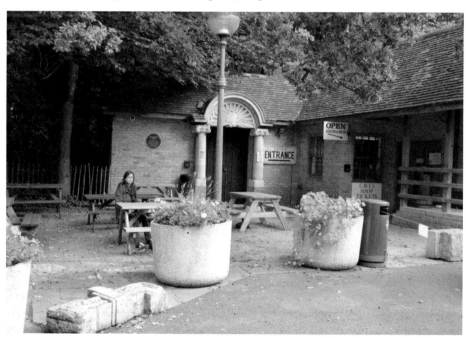

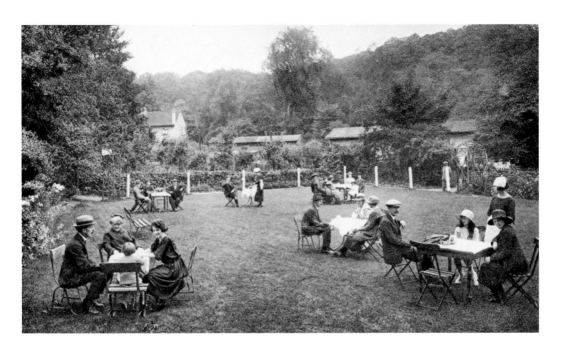

Chislehurst Caves Tea Garden

These caves are not natural but man-made from chalk and flint mining. They were worked until the late nineteenth century, and in the early 1900s the caves became a popular tourist attraction, as they remain today. At one time, it was possible to enter the caves through the gardens of the Bickley Hotel, but the area is now well developed with housing. Today, the caves are also used for dungeons and dragons games. The Labyrinthe Club operates from here at weekends, too, so don't be surprised if you meet green-faced figures heading towards the station at the end of the day!

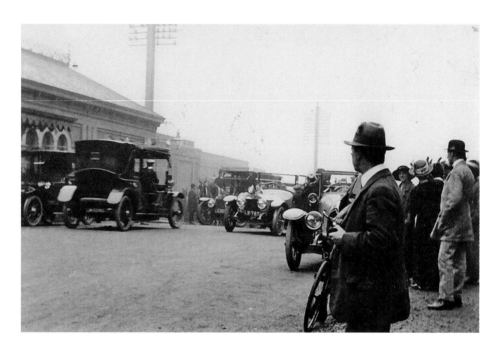

Chislehurst Station

In 1914, the station forecourt witnessed a steady stream of carriages and cars as the gentry sent their chauffeurs to ferry wounded Belgian soldiers to the newly organised Red Cross hospitals in the large houses nearby. Nowadays, partners of regular commuters jostle for position outside the station in their modern cars, and traffic jams are the order of the day. Those heading for Charing Cross and Cannon Street will be disappointed to note that, even in 1894, the journey time was advertised as twenty-five minutes, which effectively remains the same today!

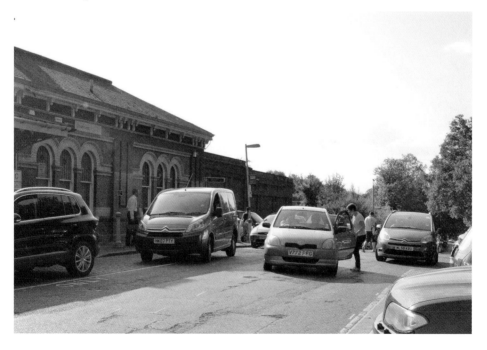

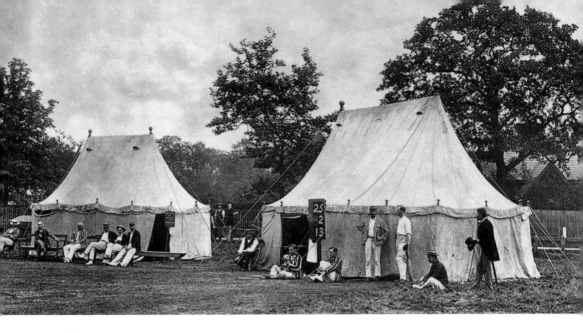

Cricket Ground

The cricket ground is part of Chislehurst Common. The Lord of the Manor granted the West Kent Cricket Club permission to use the ground in 1822, after its grounds in Bromley had been lost as a result of enclosure. The pavilion was built in 1899 and, in the summer, is still in regular use. The 1886 Metropolitan Open Spaces Act turned the common over to the people of Chislehurst, with the proviso that cricket is played there in perpetuity. The exiled Emperor Napoleon once observed to a friend that he found the game interesting, but could not comprehend why men should expose themselves to such risk without spur of financial reward. Many characters have played on the ground, from C. B. Fry to Colin Cowdray. When he was over seventy years of age in 1921, Lord Harris scored 50 not out!

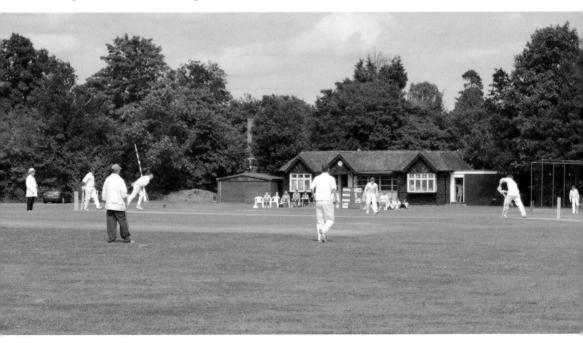

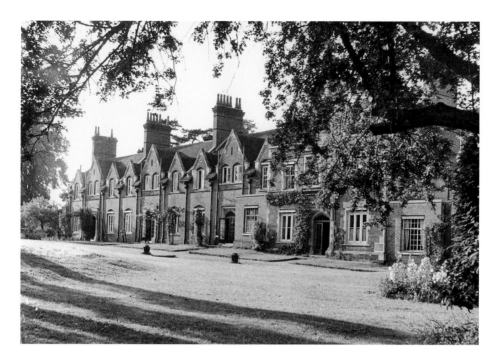

Governesses' Benevolent Institution, *c.* 1880

This was situated on the site of the present Queen Mary House. It was a long, neat building, designed by local architect E. J. May, with the lady superintendent's house in the centre and six houses on each side for elderly retired governesses. The foundation stone was laid on 4 March 1871. Although known by the title above, the correct name, which is hardly politically correct today, was the Asylum for Aged Governesses! The building was demolished in the 1960s and replaced by sheltered housing.

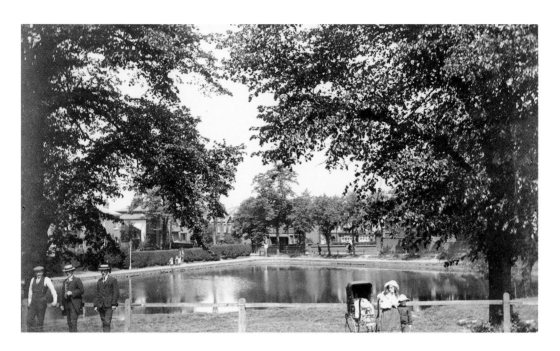

Prickend Pond, 1911

The name Chislehurst (*Ceosal Hyrst*) means a wood on gravel. Vast quantities of gravel were excavated and sold, and Prickend Pond may have been the result of such an excavation. The Commons Conservators work tirelessly to maintain the pond and clear the rotting bread that the ducks and pigeons disdain. Wildlife of the feathered variety can be seen on the pond today. Herons (*inset*), cormorants, tufted and even Mandarin ducks (*below*) are in evidence. Canada geese are attractive, if problematic, inhabitants.

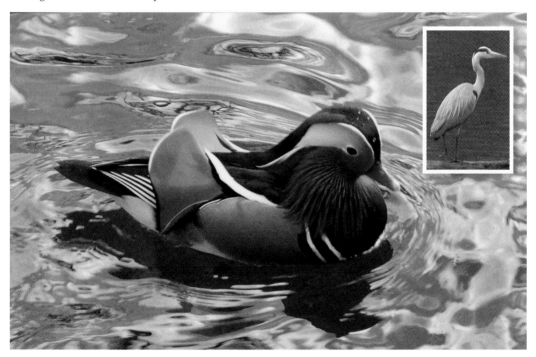

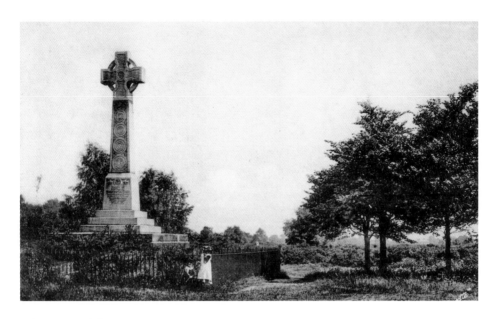

Prince Imperial Monument, *c.* 1890

The Prince Imperial was only fourteen when he came to Chislehurst with his mother. He went to the Royal Military Academy at Woolwich. He joined his fellow officers (as an observer) in the Zulu Wars, despite his mother's refusal of his request to do so. He was killed in South Africa on 31 May 1879. The huge granite cross, designed by Edward Robson in 1881 and paid for by local public subscription, stands as a monument to the Prince. On one side it bears the full names and titles of the Prince, together with carvings representing the golden bees and violet emblems of the Bonapartes. The original iron railings surrounding the cross were taken in 1940, supposedly to make guns for the defence of Britain. Now the monument can only be clearly seen from the road bearing the Prince's name, Prince Imperial Road, formerly Station Road.

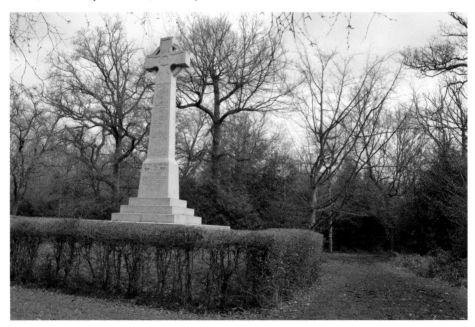

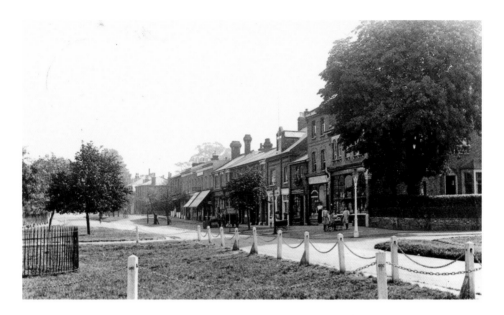

Royal Parade, *c.* 1900

This attractive parade of shops was built around 1860. The central section, Nos 7 to 11, was completed in 1870. The name was a tribute to the French Imperial family, the Empress Eugenie and her son, who arrived at Camden Place in September 1870, having fled from the disasters of the Franco-Prussian War. Royal Parade reflects the enthusiastic welcome that Chislehurst and England, somewhat surprisingly, gave to the royal family. There are not so many differences between old and new, other than a paved road instead of mud, cars instead of carts and the growth of the trees. Structurally, the shops are almost the same. Royal Parade still has a butcher's shop and a delicatessen, but restaurants and gift shops are also flourishing. The village sign commemorates the knighting of Sir Thomas Walsingham, Lord of the Manor, in 1597, when Queen Elizabeth I visited Scadbury Manor. First erected in 1953, the current sign is a replica. The bricks come from Scadbury.

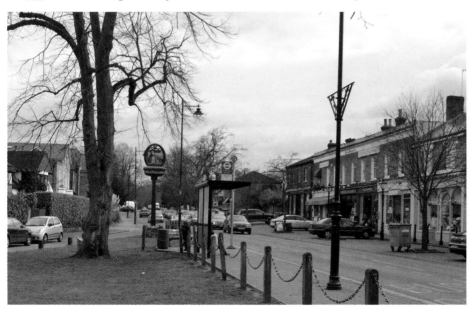

Scadbury, c. 1930

The earliest references to Scadbury are from the thirteenth century, when it was owned by the de Scathebury family. It was home to a succession of Lords of the Manor, including the Walsingham family from 1424 to around 1655. Sir Edmund Walsingham became Lieutenant of the Tower of London and had custody of many of the prisoners of King Henry VIII, including Sir Thomas More and Anne Boleyn. Sir Francis Walsingham, Secretary of State under Queen Elizabeth I, may have been born here. Thomas Walsingham IV, his cousin, did live here and was patron of the poet and playwright Christopher Marlowe, who was arrested at Scadbury shortly before his mysterious death. This picture is of the Victorian house, built by the moat but destroyed by fire in 1976. The park was purchased by the London Borough of Bromley in 1983 and is now a local nature reserve. Orpington and District Archaeological Society (ODAS) hold regular open days in the autumn, where you can see the current excavations of the medieval manor house for yourself.

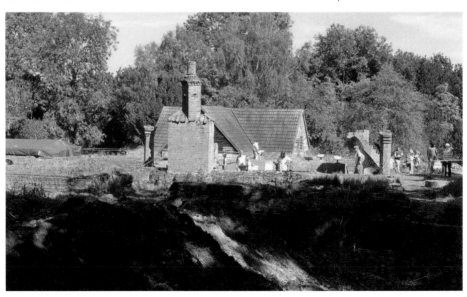

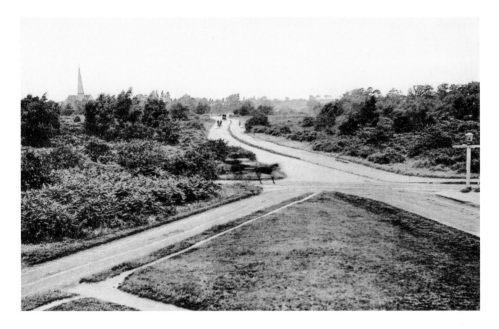

War Memorial, *c.* 1890

The war memorial, by the crossroads at Royal Parade, was unveiled on Sunday 17 October 1920 by Lt-Col. Francis Edleman, DSO. The memorial has the names inscribed of the 186 local men who died in the First World War, and a further sixty-five who died in the Second World War. The memorial, 8 metres tall, is from a design by Sir Reginald Blomfield. It is similar to the traditional Commonwealth War Graves Commission Cross and Sword of Sacrifice seen in their cemeteries in many parts of the world. It cost £1,000 to design and erect. The Armistice Day service is held annually on 11 November, starting at St Nicholas church, and the local police control the traffic very efficiently in order to maintain two minutes of silence.

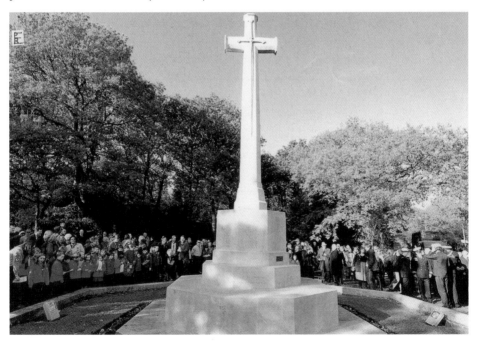

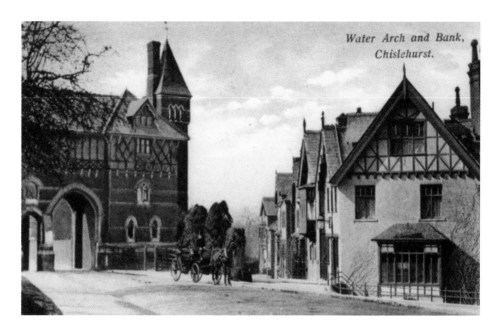

Water Arch and Bank, Chislehurst.

Water Tower

This straddled the top of Summer Hill from 1860. The water tower was built by George Wythes, a wealthy railway contractor, as a gateway to his new Bickley Park Estate. On each face of the tower, above the pedestrian archway, his coat of arms was carved in stone. There was accommodation in the tower, accessed via steep stone stairs. There was nothing else like it in the country. The water tower never actually provided a drop of water, and only succeeded in causing traffic jams for over a hundred years, until its controversial demolition in May 1963. The coats of arms were saved after the demolition. One of these was incorporated in the memorial that was eventually built in 1975 at the top of Summer Hill, where the western end of the tower once stood. Bank House, at the top of the hill, was a branch of Martins Bank. For many years, it sported the metal grasshopper sign of the bank.

Chislehurst Commons

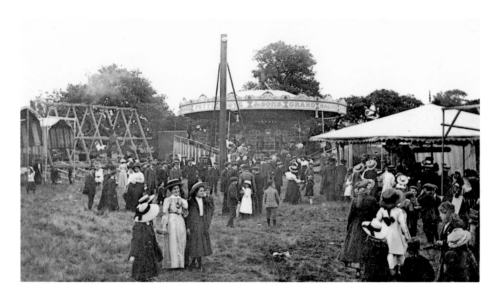

The Commons, *c.* 1910

Chislehurst is fortunate to have so much natural open space all around. However, that has not been achieved by accident. The Commons of Chislehurst and St Paul's Cray consist of about 180 acres; they are the common lands of the manors of Chislehurst and Scadbury. During the early nineteenth century, significant damage was being done to the natural beauty of the land by unauthorised digging of gravel, serious fires, the dumping of rubbish and a general lack of attention. In 1885, a group of public spirited men formed the Commons Preservation Society and, after much negotiation, the outcome was the management of the Commons within the Metropolitan Commons Act of 1866, with a Supplemental Act to include St Paul's Cray in 1888. The land is administered to this day by the Trustees of Chislehurst Commons, who work tirelessly to preserve and maintain our open spaces on a very tight budget. Under strict controls, the Commons are open for enjoyment by the public, and the travelling fairs of a bygone age have now been replaced by summer fêtes, country fairs and an open air cinema, whatever the weather!

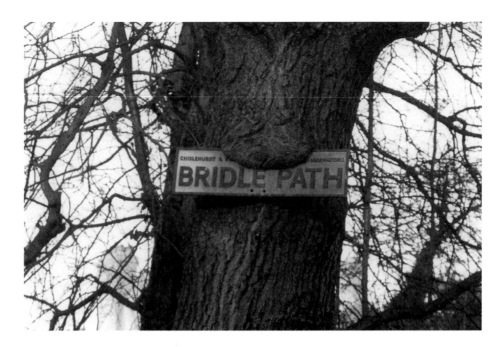

Bridle Paths, 1983

The Chislehurst Commons are a perfect setting for a gentle stroll, and many tree varieties can be seen, including alder, beech, maple, oak, Scots pine, silver birch and sweet chestnut. Trees are coppiced and felled where necessary, but self-seeding ensures continued growth. Traditional management procedures allow in light and encourage the growth of wild flowers. Change is not always obvious. However, this sign, first captured on camera in 1983 when our photographer was out for a walk along the bridle path, looks to have been almost entirely consumed thirty years later. Such is the natural rate of growth on our well-managed commons.

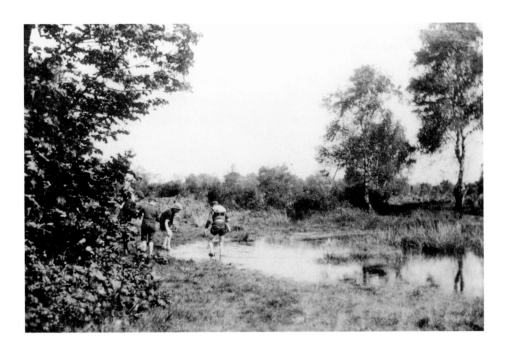

Overflow Pond, *c.* 1920

So-called from village folklore, which claimed the pond would fill up and 'overflow' onto the path that used to run through the centre of the water. The pond, to the south of Bromley Road, was a favourite place to fish for sticklebacks. This hauntingly beautiful place supports a considerable growth of bur-marigolds, a rare plant in this part of the country. The pond is now subject to the vagaries of the British climate and in dry summers can disappear. As it is surrounded now on all sides by thick vegetation, it is an almost secretive place that children merely walk past on their way to and from school.

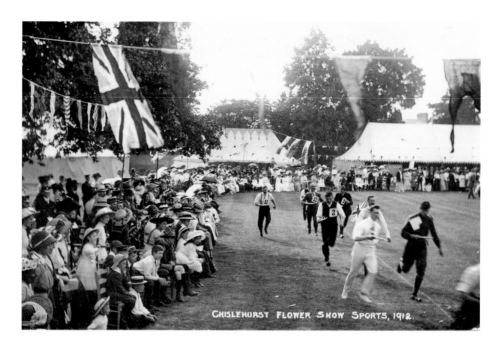

CHISLEHURST FLOWER SHOW SPORTS, 1912.

Chislehurst Races

The Commons are used to hosting flower shows, hospital fundraising and celebration events, which included races for both adults and children. The first Chislehurst Chase was held over 100 years ago, very possibly on horseback around a race track over the Commons. In 2009, the Chislehurst Chase was reintroduced as a 10k cross-country run, making two loops of Scadbury Park. The Trustees of the Commons also organise a 2k family fun run along a stretch of St Paul's Cray Common. This is now an annual event held in September, and attracts increasing numbers of entrants and enthusiastic crowds cheering them on. The runners are seen here setting off from Royal Parade.

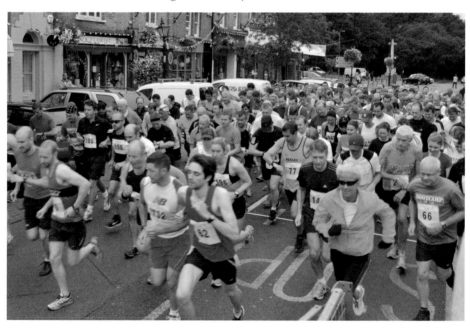

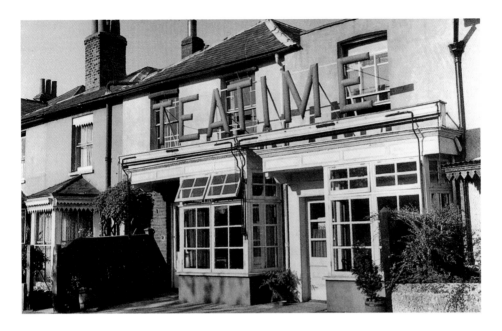

Tea Time, c. 1950
This small cottage in Church Row originally housed the general post office before the High Street post office, now Café Rouge, was opened in 1908. After that move, the cottage became a tea rooms, with its name Tea Time emblazoned for all to see. Local residents recall that, right up to the 1960s, tea was served by waitresses in neat aprons. It had a spell as a clothes shop but is now a private dwelling, in keeping with the charm of the whole row.

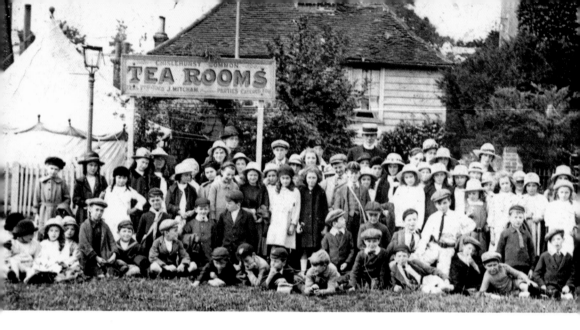

The Big Draw

The Commons have always provided open space for local children to come and enjoy themselves in the fresh air. Traditionally, Sunday school outings and other groups would head for the tea rooms on the Common. In these health and safety conscious times, outings to the Commons take a more organised approach. October sees the arrival of the Big Draw, a national campaign connecting people of all ages with museum and gallery collections in a creative and enjoyable way. Chislehurst always plays its part and attracts more and more families every year.

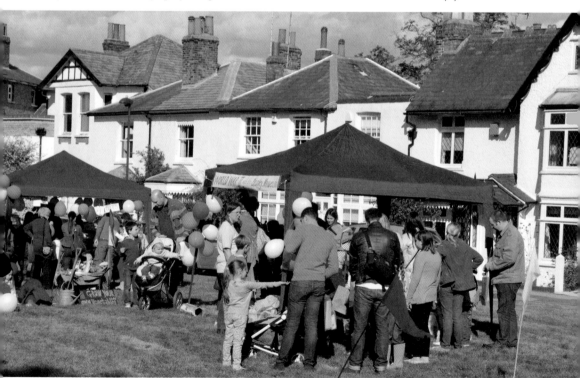

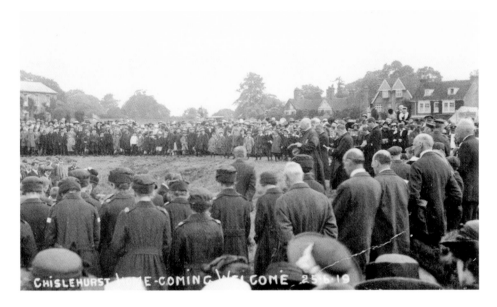

The Cockpit, 1919

On the village green area, opposite the West Door of St Nicholas church, is the Cockpit: circular, 34 feet across and marked with a slight ring of soil. If not unique, it is certainly one of the best preserved earthworks of its kind in the country. After cockfighting became illegal in 1834, the site became a centre for village activities. It was used for single stick fighting, but this was abolished in 1862 because it had become 'the resort of all the commonest and lowest class of persons'. The Cockpit was arguably the most appropriate scene of the homecoming service for the troops in 1919. The Cockpit is marked by a stone, donated by village resident Mr A. Gunn. The Punch and Judy Shows that now grace the space at village events re-enact the fighting aspect of the Cockpit, while employing the traditionally safer method of puppetry!

View of St Nicholas Church

This piece of common land at the heart of Chislehurst is part of the Commons, owned by the Lord of the Manor, protected under the terms of the Metropolitan Commons Supplemental Act 1886 and managed by the Trustees of Chislehurst Commons. There are three main parts of the Common: this view by the parish church of St Nicholas, the area around the cricket ground and Mill Place, and the largest section continues from Prince Imperial Road, across Centre Common Road to Kemnal Road. The Commons are regarded as belonging to the residents of Chislehurst, even though they are technically owned by a non-resident landlord.

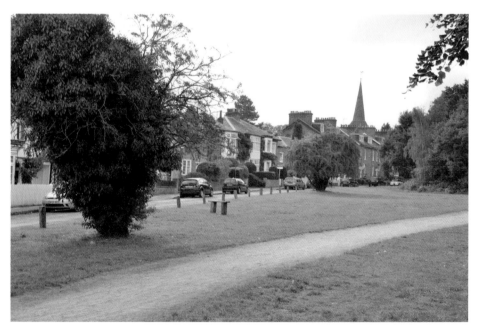

Churches

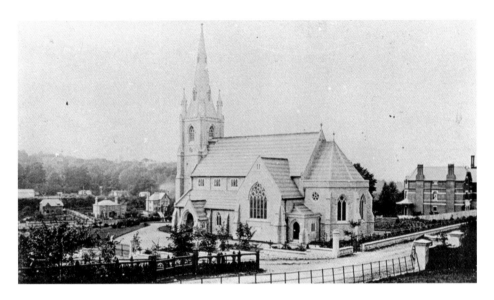

Christ Church, Lubbock Road, *c.* 1872

This church was built on 4 acres of land donated by Nathaniel Strode of Camden Park. It was set up by a group of evangelical churchmen as a low church, as opposed to the ritual high church of St Nicholas. The foundation stone was laid on 10 June 1871 by Lord Sydney (deputising for his wife) and the whole work was completed in little more than a year. Originally, the church was built with a spire, but due to the popularity of the church and the need for expansion, the existing tower was constructed in 1879. Change in Chislehurst churches is the order of the day, and Christ Church is the second of our churches to remove its pews and reorder the interior to make for more flexible space. Many pews have found cherished homes among the congregation, either as benches or as umbrella stands! Quite what Nathaniel Strode would have made of it we shall never know, but as a dynamic space it reflects a whole new direction for the next generation to worship and enjoy.

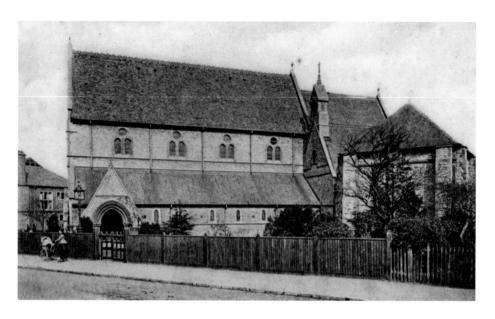

Church of the Annunciation, *c.* 1920

As Chislehurst expanded, it was clear to Canon Murray of St Nicholas church that a new church was needed for the north of the village. The Church of the Annunciation was built between 1868 and 1870 at a cost of £10,000, partly from Canon Murray's share of the proceeds from publishing *Hymns Ancient and Modern*. The church is by James Brooke and has Italianate and Byzantine features. It is near unique, both for its separate tower, which was completed in 1930 in memory of Canon Murray, and for its flying buttress; this is rare for a small English church. The church narrowly missed being bombed in 1944, but the neighbouring cottages took a direct hit. A doctor's surgery now occupies this central location.

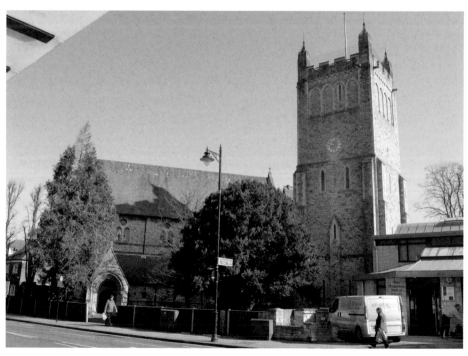

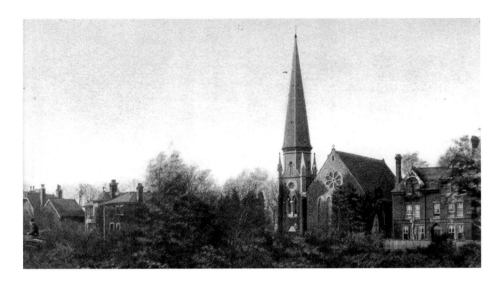

Methodist Church, *c.* 1880

Originally the Wesleyan church, this is a large and impressive ragstone building facing the Common on Prince Imperial Road. The land for the church was donated by Nathaniel Strode, then owner of Camden Park. George Chubb, 1st Baron Hayter, the grandson of the founder of Chubb & Sons Lock & Safe Co., largely covered the costs of construction. Work began in 1868, and after a disaster, when a violent storm all but destroyed the tower, the main body of the church and its steeple were completed in 1870. The original construction cost was £5,800. The British Institute of Organ Studies lists the organ as being of Grade II significance; it has 1,600 pipes, many of them ornately painted, and it was originally pumped by hand, but thankfully for the church wardens this is no longer the case! The interior of the church has recently been splendidly remodelled, so that it can serve as a community and arts space when not in use as a church. The glass entrance opens onto a new atrium and reveals the first church in Chislehurst to remove its pews. The three-storey mansion next door to the church, which formed the manse, has now been replaced by a smaller modern house and adjoining apartments.

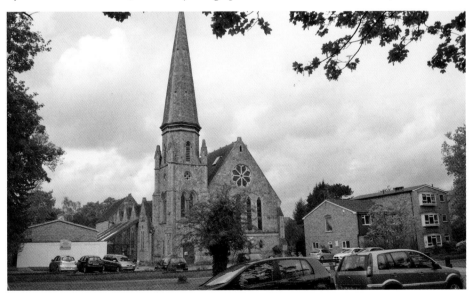

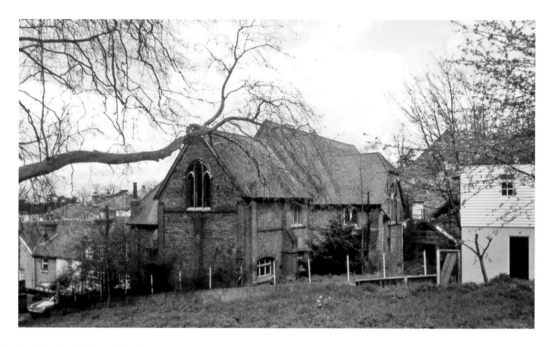

St John's Mission Church, *c.* 1930

Mill Place was built for working people, taking its name from the working windmill on the Common. Corn was ground two days a week for a nominal fee of one penny a bushel. St John's Mission church was erected in 1886 at a cost of £1,850. It was deconsecrated in 1933, put to industrial use in 1994 and demolished in 1998, after it became dilapidated. A charming terrace, known as Eugenie Mews, was built on the site. Only one other church in Chislehurst had a shorter life – St Aiden's on the Edgebury Estate (1956–74).

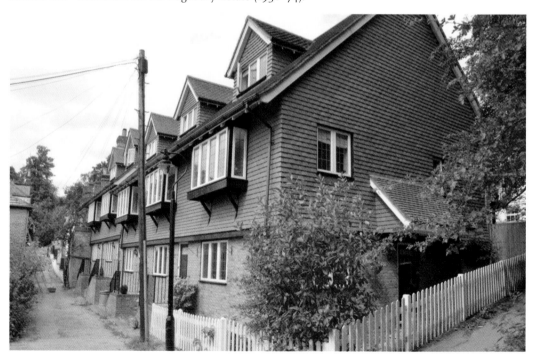

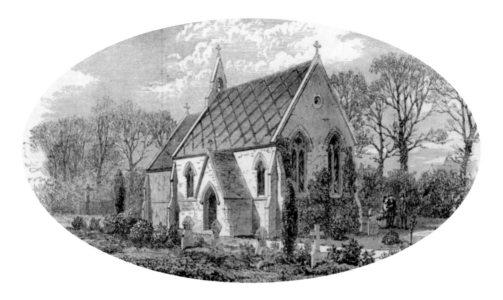

St Mary's Catholic Church, *c.* 1860

Built in 1854 by the Catholic Bowden family of Coopers, this little church achieved international recognition when the exiled French Emperor died in January 1873. His funeral procession to the church took half an hour and was attended by thousands of mourners and sightseers. The funeral of the Prince Imperial in June 1879, also at St Mary's, attracted an estimated 100,000 people. The memorial side chapel was built in 1874 by local architect, a Catholic convert, Henry Clutton, who refused to take a fee for his work. The Empress wanted to build a large mausoleum on the site to the glory of her dead, but the local Protestant landowner, Joseph Edlemann, refused to sell the required land. The bodies of the Emperor and his son were eventually removed in 1888 to St Michael's Farnborough in Hampshire, where the Empress had commissioned a grand mausoleum. In the graveyard today are many interesting headstones, including that of the daughter of Kitty O'Shea and Charles Parnell, whose birth caused a significant setback in Parnell's career and the Irish Home Rule issue. There is also the grave of Dr Charles West, founder of Great Ormond Street Hospital.

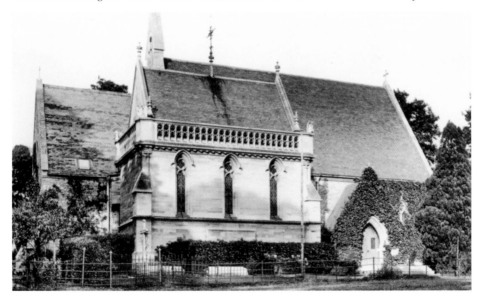

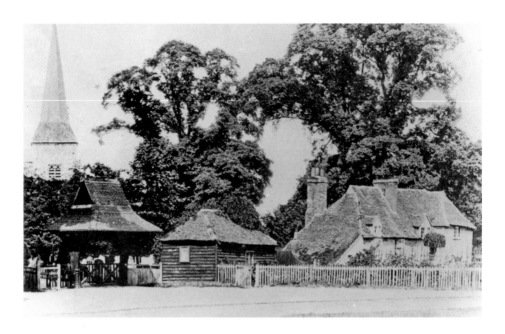

St Nicholas Church, *c.* 1880

There has been a church on this site since Norman times, and possibly earlier. The church, in its picturesque setting, contains many historic memorials, especially in the Scadbury chapel. There are remains of a late Saxon or early Norman window in the west wall. The wonderful church clock, which chimes for all to hear, dating back to 1858, is of particular horological interest. Manufactured by F. Dent, it features a possible prototype three-legged double escapement (pendulum movement) for the Big Ben clock. Canon Francis Murray was rector of the church for over fifty years from 1846, during which time he wrote that familiar hymn book *Hymns Ancient and Modern*. Little has really changed over time. The cottages at the front of the churchyard appear on the earliest map, dated 1680, and were demolished in 1892. The church now has wheelchair-friendly access, which is also a boon for buggies.

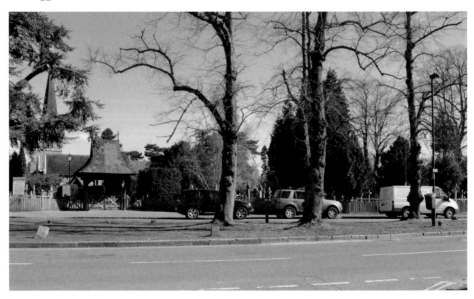

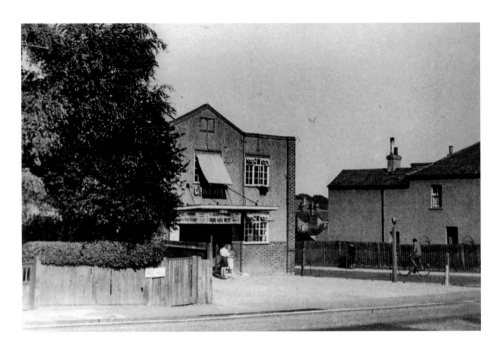

St Patrick's Roman Catholic Church, *c.* 1950

Formerly a cinema from 1930, St Patrick's was converted to a Roman Catholic church in 1961. Many local people knew it better as the 'bughutch'! The last films to be shown there were *Some Like it Hot*, starring Jack Lemmon and Marilyn Monroe, and *The Horse Soldiers*, starring John Wayne. The church was opened and dedicated on St Patrick's Day, 17 March 1961. The projection room is now the organ loft, the ticket office is now a holy water stoup and where the screen was, is now the altar. The floor slopes downwards and the seats are still the tip-up type, and can be unusually noisy during moments of prayer!

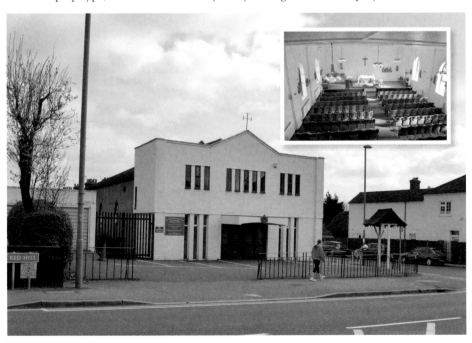

Houses

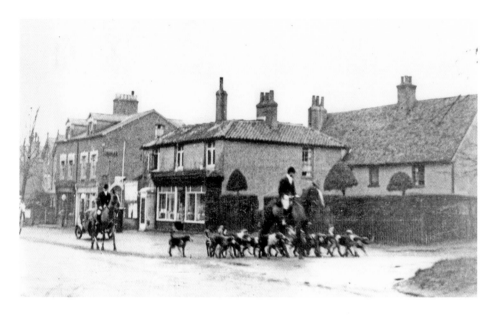

Abury, c. 1950

Standing on the corner, opposite the Bulls Head, was the old bakers shop, the home of Arthur Battle, author of *Edwardian Chislehurst*, a book still available today. The shop became Milestones, complete with a phone box and petrol station to one side. Next door, on the other side nearest Bull Lane, is Abury, the oldest complete house in Chislehurst. Although now completely covered in stucco, this is a timber-framed house, of the type found in the Weald of Kent, with walls of plaster infilling. It may date back to Queen Elizabeth I.

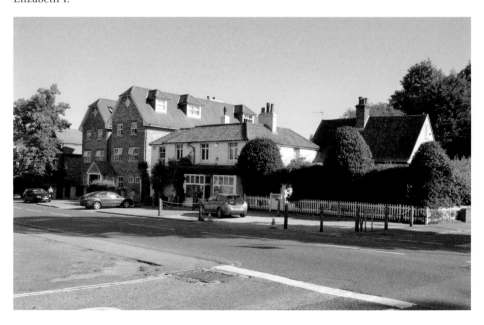

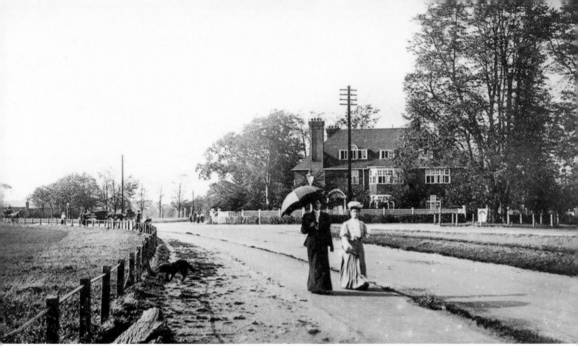

The Cedars/Hangman's Corner, c. 1910

This attractive house, prominently positioned on Camden Corner, was built in 1894 by builder William Willett from designs by Ernest Newton, in the early Arts and Crafts style. The Cedars sports a blue plaque in memory of Willett, the instigator of Daylight Saving Time. He is buried in St Nicholas churchyard, and a sundial was erected in his memory in the National Trust woods alongside St Paul's Cray Road. The formerly quiet junction opposite the Cedars is colloquially known as Hangman's Corner, and a stone marks the site of the gibbet. Today, the gruesome scenes relate more to the build-up of commuter traffic heading for Bromley and car drivers taking risky moves at the mini-roundabout.

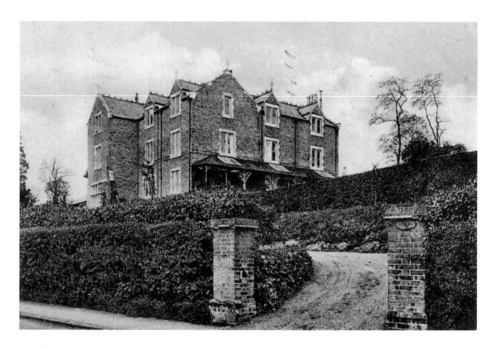

Coed-Bel, *c.* 1865

This once proud house, standing prominently on the slopes of Camden Park, was built in 1865 for William Mostyn, a gentleman with Welsh heritage. Coed-Bel means beautiful woodland in Welsh. The house had a number of institutional reincarnations over the years. It was a private school for girls from 1877 until 1939, when it became a prisoner of war camp, housing mostly Italians. After the war, Coed-Bel opened as a hostel, providing accommodation for MOD apprentices managed by the YMCA. The house remained in use until 1965, but work on its upkeep proved untenable. The house lay empty for years and was finally condemned in 1972. In 1992, the land was finally used for homes again and today's image of several imposing new builds remains prominent on the Lubbock Road landscape.

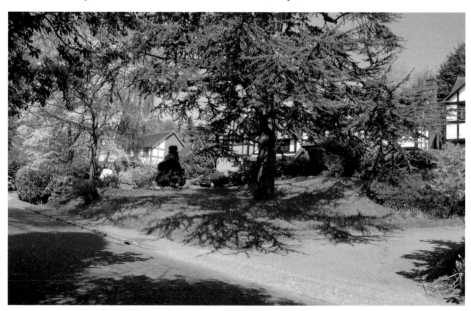

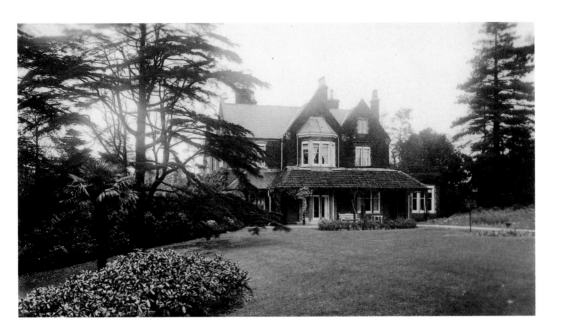

Cromlix, *c.* 1900

This elegant mansion was typical of the homes built for the wealthy Victorian businessmen who came to live in Chislehurst following the arrival of the railway, with its connection to the city of London. Cromlix was the home of William Lund of the Blue Star shipping line; he moved here from Waratah, a substantial pile in Chislehurst West. All that remains now is the gatepost on Summer Hill, the house having been knocked down and a new housing estate built in its place by Wates in 1972. In 1981, Cromlix Close was the last part of the development.

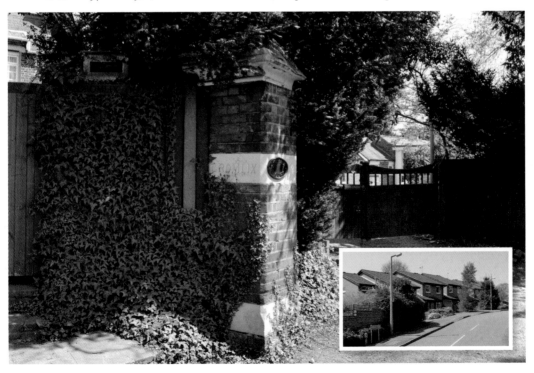

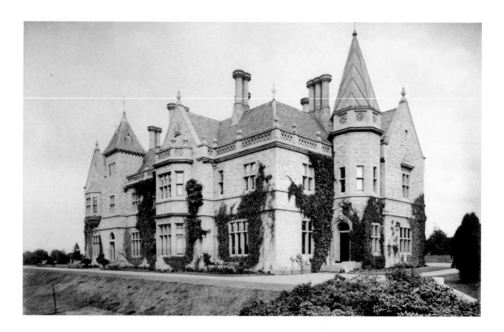

Foxbury, *c.* 1900

Foxbury is arguably the hidden jewel in Chislehurst's crown, described in *The History of Chislehurst* as a 'fine mansion, beautifully situated on an eminence'. It is the largest remaining Victorian home in the area and sits proudly to the east of Kemnal Road. The house, designed by architect David Brandon, was built in 1877 for Henry Tiarks, a partner with J. H. Schroder & Co. The family continued here until 1938, when Foxbury was sold to the Church Missionary Society. At one time, it was also a training centre for a building society. In recent years, it has been restored for use again as a family home. In 2009, it nearly had a celebrity tenant, when Michael Jackson took a lease on the house for his use during his planned O2 concerts. He died before he took up residency.

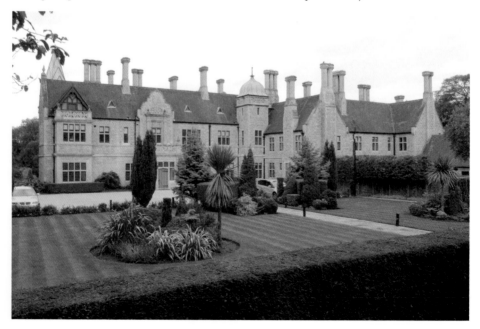

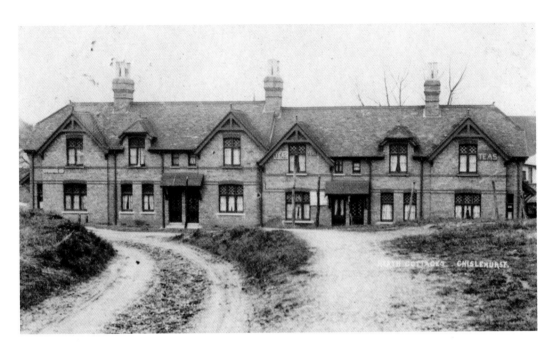

Heath Cottages

This charming row of cottages has changed little externally since its Victorian beginnings. Not exactly on a heath, more specifically on Chislehurst Common, the land in the old picture looks far more open and exposed than it appears today. The cottages remain tucked away, hidden from view from the traffic on Old Hill, and most likely only known by visitors to the Rambler's Rest public house next door. The cottages are on the boundary of what was the distinctive village of Mill Place, a self-contained area of cottages, housing working families, servants to the nearby 'big' houses, rat-catchers and millworkers.

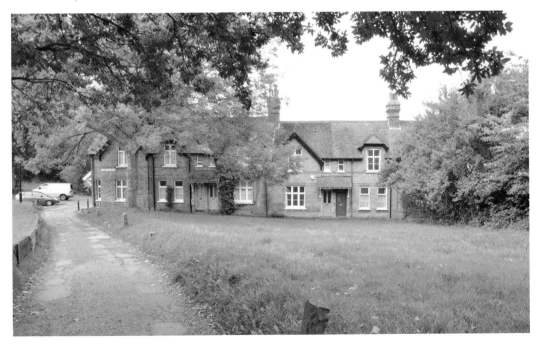

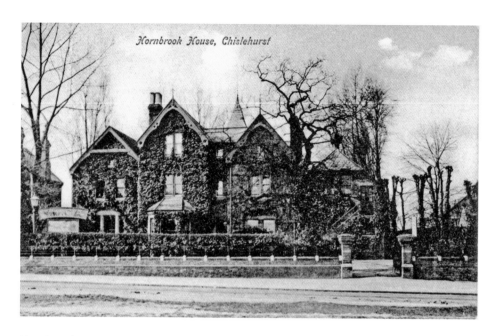

Hornbrook House, Chislehurst

Hornbrook House, *c.* 1900

Once a boarding school for 'young gentlemen who were well grounded in classics and mathematics', says Arthur Battle in *Edwardian Chislehurst*. Boarders were charged 50–80 guineas per year. The school also took day pupils, including our very own Sir Malcolm Campbell, along with one of the Bentley Boys, Sammy Davies, and all-round sportsman C. B. Fry. The headmaster in 1891 was Oxford-educated Hugh Vaughan Pears. Along with Hollington House next door, Hornbrook became a Red Cross hospital in 1914, one of several in Chislehurst during the First World War. The name Hornbrook continues to this day as the name of the car park at the top of the High Street, where, every third Sunday of the month, the Chislehurst Farmers' Market gathers to sell home-grown and crafted produce.

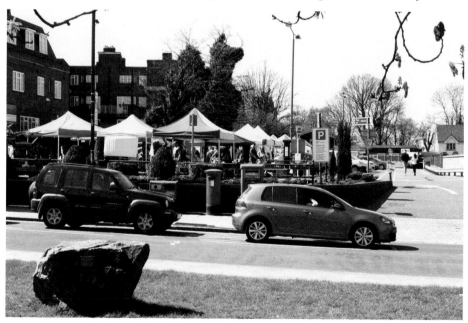

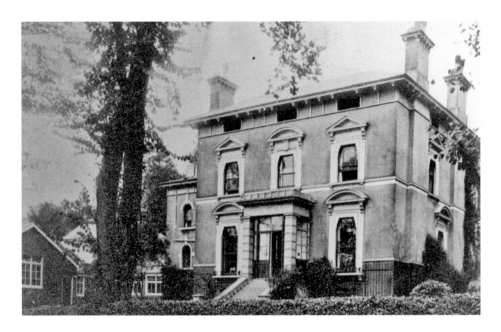

Lammas, 1911

Lubbock Road was named after the Victorian polymath Sir John Lubbock. Born in 1843, Lubbock lived at Lammas (in what was then called New Road) from 1861, with his wife Ellen and young family. It is from this house that he wrote his bestseller, *Prehistoric Times*. The family left Chislehurst in 1865, on the death of John's father. He became Sir John Lubbock (later Lord Avebury) and entered Parliament. It is Sir John to whom we should be grateful for the institution of Bank Holidays and for his championing of the protection of ancient monuments. The house went on to become St Hugh's Prep School, a First World War hospital for the wounded, and a children's home of the Barbican Mission for the Jews, providing shelter for young children rescued from Prague in 1939. The house was demolished and replaced with four modern homes in 1962.

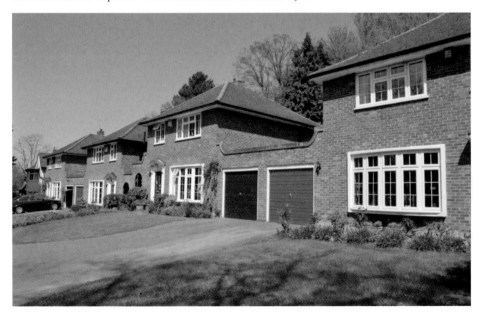

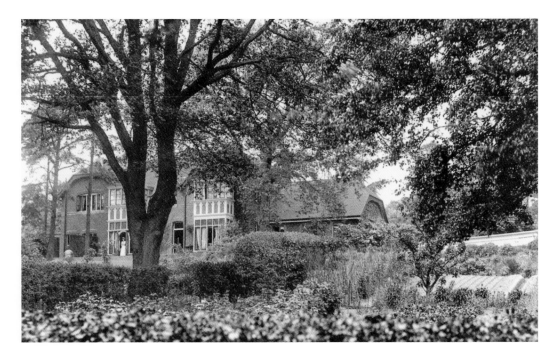

Luson House, *c.* **1900**

This fine example of a late Victorian house and gardens is typical of the red-brick-style houses built on the Camden Park Estate at the end of the nineteenth century. The house would have had an impressive view over the estate, which later became the golf course. Luson House no longer exists, having been destroyed by a flying bomb in 1944, resulting in a tragic loss of life. Foxholme Close was built on the site; where there was once only one house, there are now several.

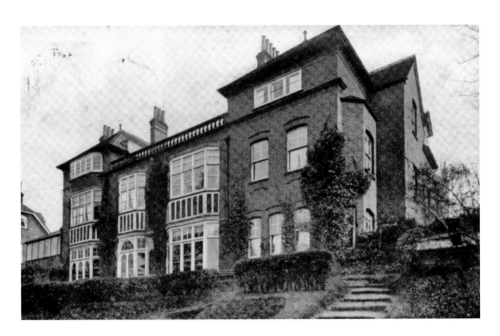

Morland House, 1906

Deep in Susan Wood, off Old Hill, is Morland House, a substantial red-brick house, built around 1894, which was once home to St Hugh's Preparatory School for Boys. The old postcard was taken by renowned photographer Oscar Hardee, who lived on Summer Hill. Before moving to Bickley, the school (founded in 1906) spent a few short years in Chislehurst, in Susan Wood, and later at Lammas, Lubbock Road. Former pupils include Tommy Disher, nephew of Richmal Crompton and her role model for *Just William*, and also Alan Watts, a Chislehurst son, who went on to lead the flower power movement in San Francisco. The school now thrives as a co-educational establishment in Oxfordshire. Morland House was refurbished in 1992 and is now divided into flats.

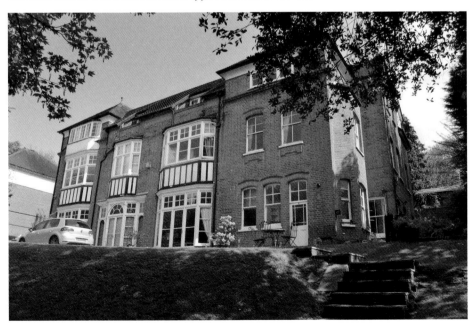

Norland Institute, *c.* 1942

The Norland Institute, known originally as the Training School for Ladies as Children's Nurses, came to Chislehurst at the end of 1941. The institute occupied four large houses: Oakleigh, an Edwardian former hotel at the top of Summer Hill, and, across the road, Millfield (the site of the former windmill), Mayfield and Winton. The institute ran its own farm during the war and was intent on building a brand new college on the Mayfield site. However, the financial crisis of 1964 put mortgage prospects on hold. Wates, the developers, became interested in buying the land and the Norland Institute left Chislehurst in 1967. The old houses did not stand the test of time and Wates built a modern housing estate on the land. They retained the link with the eponymous nannies in the names Norland Crescent and Norland Gate.

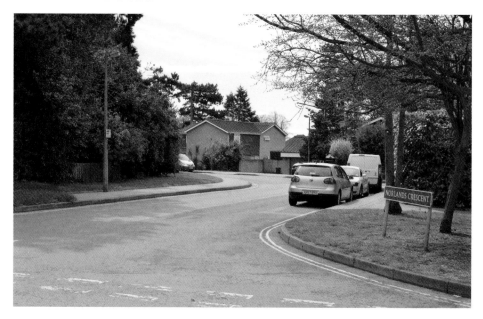

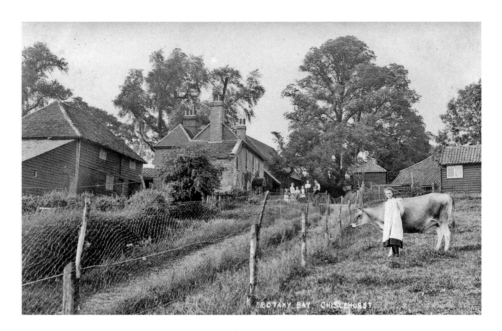

Tong Farm

Although surrounded by suburbia, the National Trust-owned Hawkwood Estate is like real countryside, with ancient hedges, streams and woods. Walking down the intriguingly entitled Botany Bay Lane (named after our own Lord Sydney's destination for convicts, surely?) one comes to Tong Farm and Goodlands Cottage. The farm was acquired in 1975 with the proviso that farming should continue here to preserve its rural character. The cottage has been renovated following fire damage and is rented from the National Trust. There are wonderful views here southwards across the open land looking towards Petts Wood and Orpington.

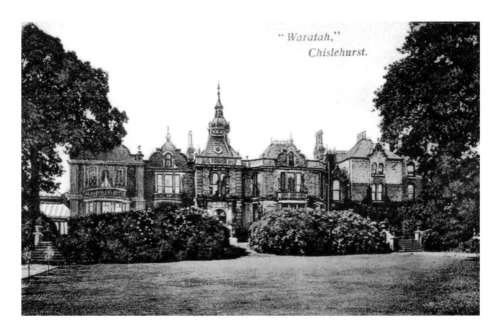

" *Waratah,*"
Chislehurst.

Waratah, *c.* 1885

The original house on this site was built in the late 1880s for William Lund of the Blue Anchor shipping line. Waratah is a vibrant red shrub, the national emblem of the Australian state of New South Wales; Lund had Australian connections. The house changed names and became Walden Manor, but was virtually destroyed by a fire resulting from a bomb in 1944. At the time, it was storing the furniture stock of Harrison Gibson. Finally demolished in 1960, Ravensbourne College of Design opened on the site in 1976. The college moved to its new site at the O2, part of the University of Greenwich, in 2010 and the buildings were bulldozed for the development of a new housing estate. The name Waratah remains as the name of one of the newly laid out roads.

Sir Malcolm Campbell, January 1949
The son of a diamond merchant, Malcolm
Campbell was born at Rossmore, Chislehurst,
on 11 March 1885. The house still stands, but
is now called West Witheridge. Campbell
attended Hornbrook House School in
Chislehurst and appeared in a performance
of *Alice in Wonderland* in the village hall.
Campbell's adventures locally involved
speeding down Summer Hill on a bicycle,
for which he ended up in the magistrate's
court, and flying aeroplanes in the early
1900s, using the cricket pitch as a landing
strip. The family moved to Northwood on
Manor Park Road in 1894, but after a row
with his father in 1908, Campbell left home
for good. Following a career in Grand Prix
motor racing, he was knighted in 1931. In
1935, he became the first man in the world to
reach 300 mph on land. In 1939, he achieved
the world water speed record of 141.7 mph, a
record he still held when he died in 1948.

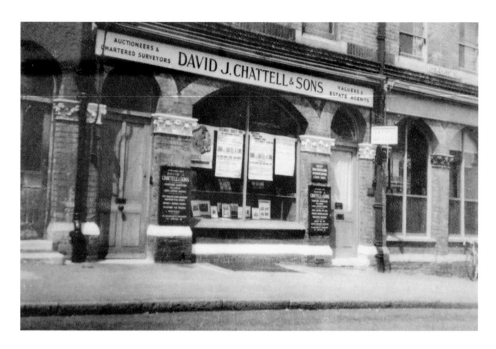

David Chattell, *c.* 1890

David Chattell established his estate agency in Chislehurst around 1870, coinciding with the arrival of the railway, which brought the emerging wealthy Victorian middle class to fashionable Chislehurst. David Chattell already had his business of auctioneers and chartered valuers in Lincoln's Inn, the address that can be seen on the estate particulars of Camden Park as it went under the hammer to William Willett in 1890. Chattell may have profited from the commission on this sale, but it is interesting to note that as one of the first Commons Conservators, he was responsible for preventing Willett from developing 300 houses on the estate. The business was managed by the Chattells; the eldest son, Frances, continued to run it from Lower Camden after the First World War. Today, the enterprise is the popular café, Mustard.

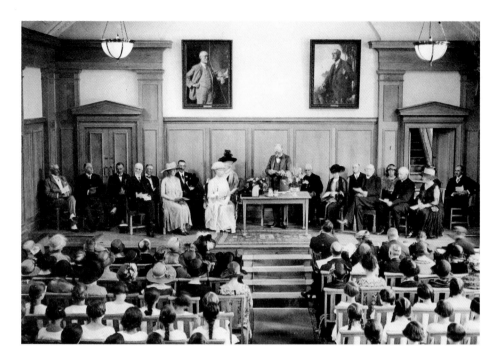

George Hayter Chubb, 1848–1946

Chubb was a notable resident of Chislehurst. The grandson of the founder of Chubb & Sons Lock & Safe Co., he was managing director and chairman until his death. He largely financed the building of the Methodist church next door to Newlands, his home on Chislehurst Common. He was also a founder of Farringtons School in Chislehurst. He is pictured here accompanying Queen Mary on a visit to the school in 1925. He was knighted in 1885, created Baron Newlands in 1900 and raised to the peerage as Baron Hayter of Chislehurst in 1927. The Chubb safe featured here is still in situ at another of our schools, Coopers Technology College.

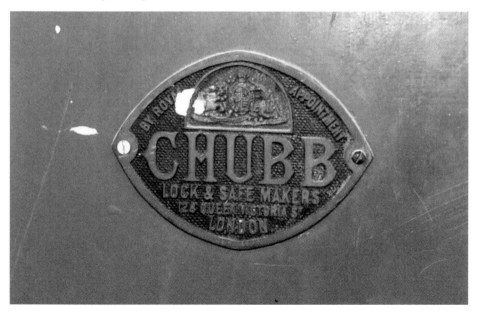

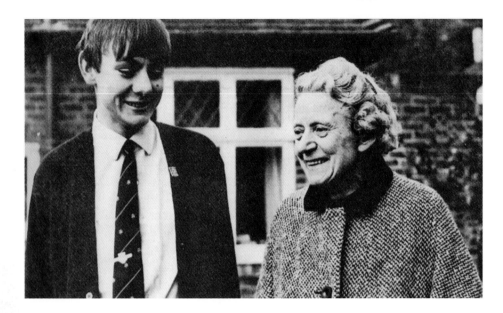

Richmal Crompton, 1968

By the time Miss Richmal Crompton came to live in Chislehurst, she had already published twenty-eight *Just William* books. The first was published in 1922, when Richmal was thirty-one, and the last of her thirty-eight books was published in 1970, a year after her death. In 1954, she moved to Beechworth, a bungalow on Orpington Road in Chislehurst, in the woods just beside Leesons Hill roundabout. She was a churchgoer and supporter of the Conservative Party. She was also interested in mysticism, reincarnation and the occult. She died of a stroke in Farnborough Hospital, Locksbottom. Her funeral service was held at St Nicholas church and her final resting place is in the grounds of Eltham Crematorium. The current owners of Beechworth, John and Evelyn Barclay, have lovingly restored the house and can proudly point out Richmal's study, where she continued to write until her final days. They have kindly recreated for us this scene of Richmal with her great-nephew, Edward Ashbee, in the back garden of Beechworth.

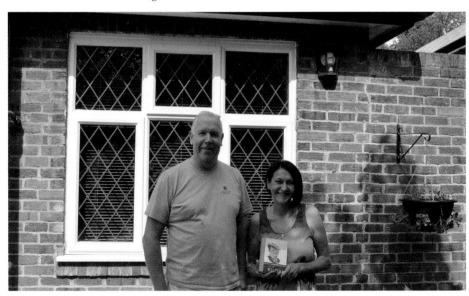

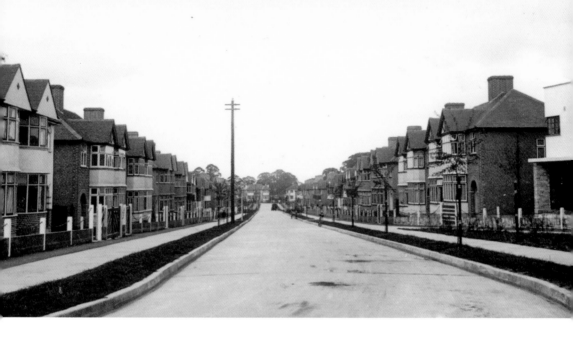

Siouxsie Sioux, 1960

This singer-songwriter grew up in Woodside Avenue. Her rock band, The Banshees, performed from 1976 to 1996, producing a string of hit singles. Woodside Avenue is no longer the clear road pictured here; it may be tree lined, but it is now also lined with parked cars. It is rumoured that, just one road away, other pop stars frequented Chislehurst: the lads from Status Quo supposedly visited their girlfriends, who lived at the Tudor House flats in Green Lane. In 1977, Siouxsie sang about 'Hong Kong Garden Take-away' – this was her local Chinese fast-food outlet. It is still there today: the Noble House, on the High Street.

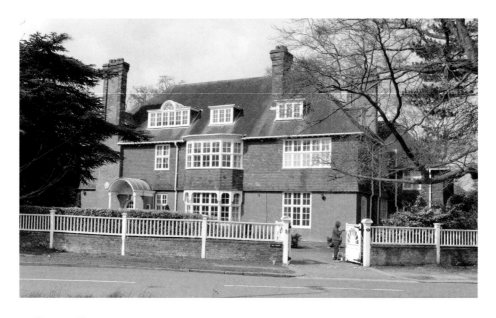

William Willett, 1856–1915

A British builder born in 1856, Willett purchased the Camden Park Estate in 1890 and built the Cedars and several houses in Camden Park Road. From his stables in Lubbock Road, he rode is horse across the Commons and into the woods. As he rode, he noticed how many blinds were down in the early morning and began his tireless campaign for 'Daylight Saving Time'. He published a pamphlet in 1907, *The Waste of Daylight*, suggesting that the clocks be advanced by twenty minutes at 2 a.m. on successive Sundays in April, and be moved back by the same amount in September. Churchill became a supporter and the scheme was introduced in the Defence of the Realm Act 1916 as part of the war effort to save coal. However, Willett didn't live to see his idea come to fruition. He died of Spanish Flu in March 1915, aged just fifty-eight. He is remembered by a memorial sundial in the National Trust Woods, which bears his name to this day. The Chislehurst Society recently gained Heritage Lottery funding to put his name firmly on the map.

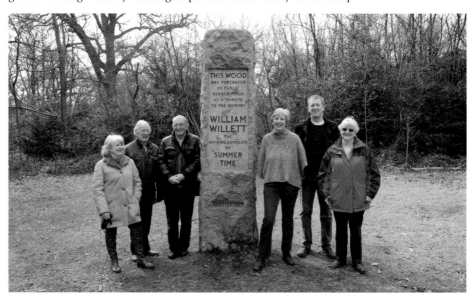

Pubs

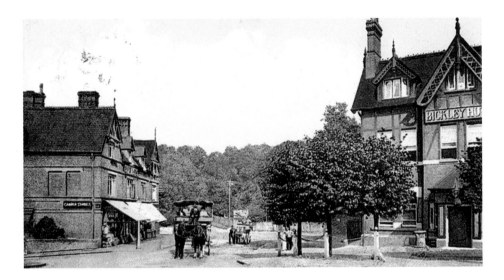

The Bickley, *c.* 1890
This hostelry has seen many changes of ownership and was at one time known as Ye Olde Stationmaster. Originally, the railway station for Chislehurst was at the foot of Old Hill, opposite the pub; what is now the fish and chip shop was once the ticket office. At the turn of the century, the owner of the Bickley Hotel had the bright idea of opening the disused chalk mines behind his hostelry and charging the public for guided tours. The hoarding in the centre of the old postcard image is an advertisement for the caves. The carriage in the foreground went to Bromley on Thursday market days, leaving from the Bickley Hotel. The journey cost 6*d*. In a later 1910 image, showing both cars and horses, the sign states 'To Car Men. It is inadvisable to attempt this hill with a heavy load, the Station Hill [now known as Summer Hill] has a much better gradient.'

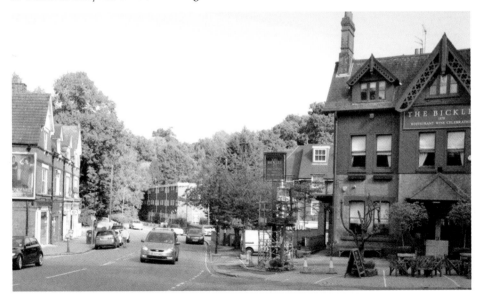

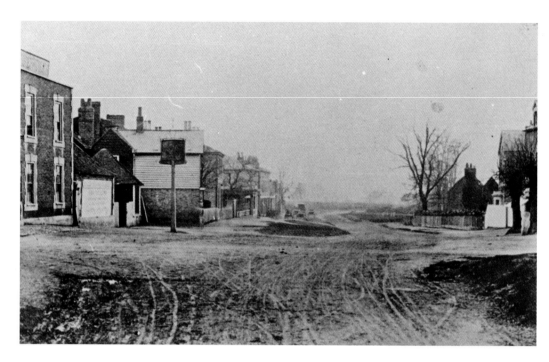

The Bulls Head, *c.* 1870

This pub was built after 1753, although it is mentioned on a 1680 map. It was, at one time, connected with Warwick the Kingmaker, Richard Neville, whose family were Lords of the Manor of Chislehurst. The name of the pub is probably taken from the badge of that family. There is, however, nothing earlier than eighteenth century in the present building. Note the state of the ancient 'roads', muddy and indented with wheel marks. At least today the tarmac provides a firm surface for the cars that pull up at the pub.

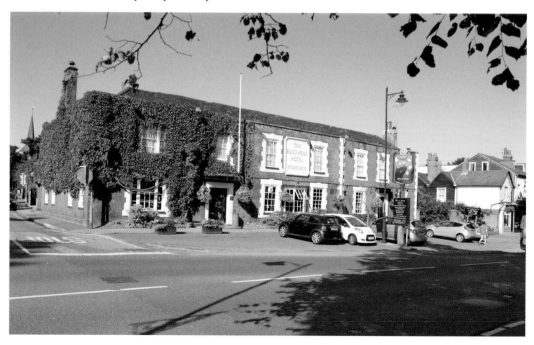

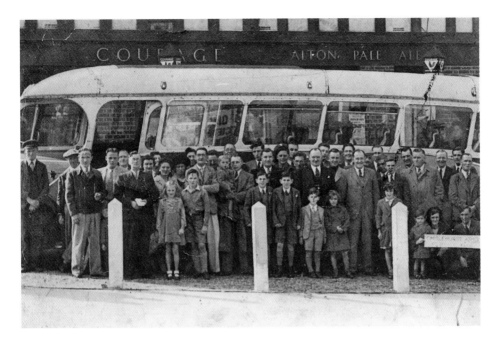

The Gordon Arms, 1959

Established before 1869 in Chapel Lane (now known as Park Road), this pub was run by the Crowe family from 1885. The reason for the name cannot be verified, but it is known that General Gordon, of Khartoum fame, was a visitor to Chislehurst from nearby Gravesend in 1869. Eugenie Crowe was still landlady in 1936 when the pub was demolished to allow the corner of Green Lane and Park Road to be widened. Opened by Courage & Co., the result was a contemporary building a few yards from the original. It is an unusual style for this part of Chislehurst, where more formal brick or thirties-style pebbledash predominate.

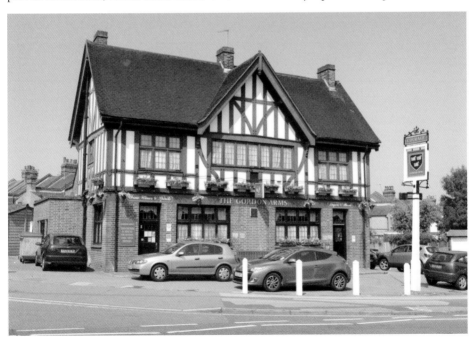

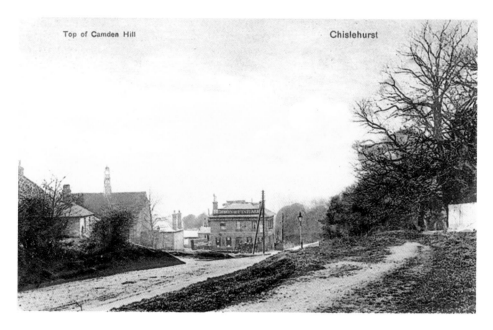

The Imperial Arms

This pub used to be called the Windmill, after the windmill that was situated on the Common at the top of Summer Hill. This also explains the naming of Mill Place, the community within which the pub is set. Mill Place was developed in the late nineteenth century, with its own police station and church. The windmill was erected in 1796 and remained in situ for eighty years. After the windmill was demolished, the pub took on its new and altogether grander title: The Imperial Arms. It was named after the exiled French Emperor, Louis Napoleon III, who, in 1871, had taken up residence at Camden Place, just up the hill. The pub is on the edge of Old Hill, the former main road to Bromley, known then as Bromley Road. The pub is hard to see by the motorist going down this narrow road, hidden as it is by trees and estate agents' boards.

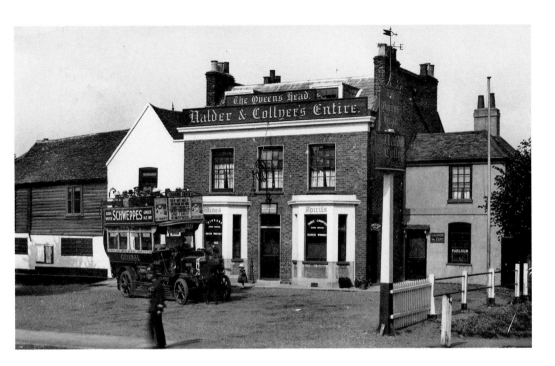

The Queen's Head

This pub is the oldest building in the village. The central part is Georgian, but the northern end is much older and until the 1980s, contained 2-inch-thick oaken vats, dating from Stuart times. Now, seemingly named after Queen Elizabeth I, it was originally called the King's Head. It used to advertise 'Comfortable apartments overlooking tasteful gardens and rural scenery, and good stabling' and, being located next to the village pond, the outlook today does seem semi-rural.

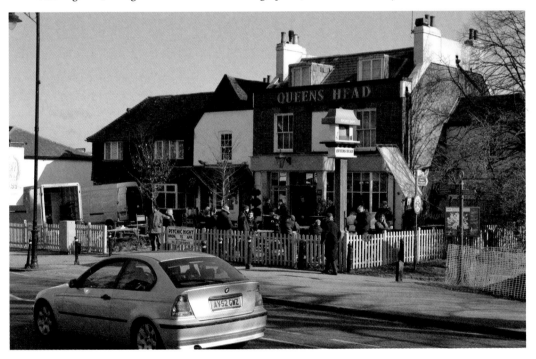

The Ramblers Rest, *c.* 1890

It is understood that this pub was originally called the Miller's Arms, reflecting the nature of the community it served. There has been a public house on this site since at least 1807. With later additions, the current building dates from a century later. Rumour has it that the bodies taken down from the gibbet on nearby Hangman's Corner were laid out in the cellars of the pub before removal to the mortuary. Over time, the pub has been gradually enlarged and modern facilities created without disturbing its old-fashioned charm. The pub's almost rural setting, on the Common beneath Summer Hill, makes it a hidden gem.

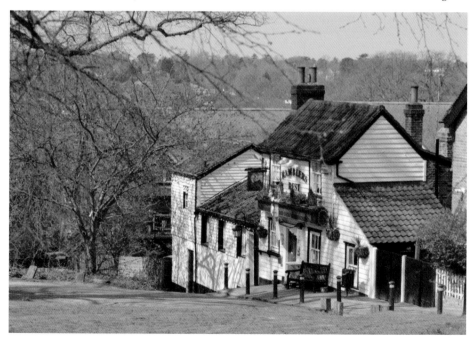

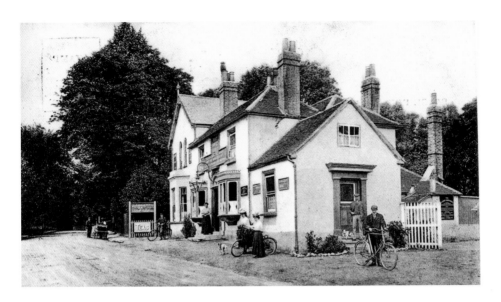

The Sydney Arms, 1908

Hidden away down Old Perry Street, this pub used to be on the main route north out of Chislehurst. It served the busy traveller on what was then Perry Street: a thriving community with a laundry, a school, shops and this public house. The pub was originally called the Swan, but its name was changed in honour of Lord Sydney, who was the Lord of the Manor of Scadbury and Frognal. Sydney, Australia, and Sydney, Nova Scotia, are named after Lord Sydney (1733–1800), who, as Secretary of State, recommended the first transportation of convicts to Botany Bay. In more recent times, the boxer Henry Cooper, a friend of Doug Chapman the landlord, displayed his belts at the pub. Henry was regularly seen training here, running around the Commons. The newer road was built in 1956 and the pub now enjoys a relatively peaceful location, slaking the thirst of walkers from Scadbury Park.

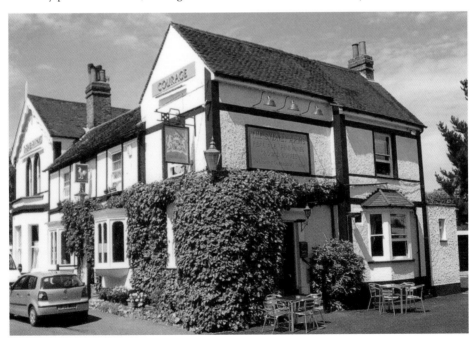

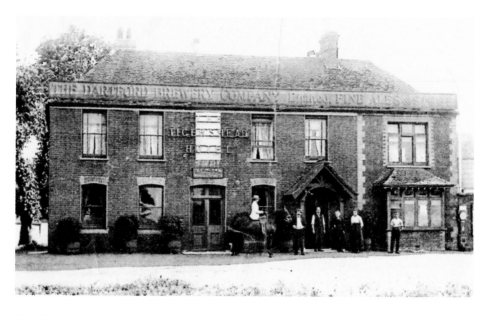

The Tiger's Head, *c.* 1890

This ancient hostelry derives its name from the tiger crest of the Walsingham family (who left Chislehurst around 1655), and was therefore probably in existence as far back as the fifteenth century. Some of the interior is quite possibly original. It is one of the few dwellings to appear on a map of Chislehurst from around 1680. In 1773, Revd Francis Wollaston, Rector of Chislehurst, dined here with sixty of his parishioners on the occasion of the 'beating of the bounds'. In 1814, the landlord, one John Milton Pugh, was called upon to feed the rector's 2,000 guests on the green, to commemorate the Treaty of Paris. On 10 April 1822, the members of the West Kent Cricket Club had their inauguration dinner here. A pint of wine was allowed for each member, man or boy. After those liquid dinners, they went back to play!

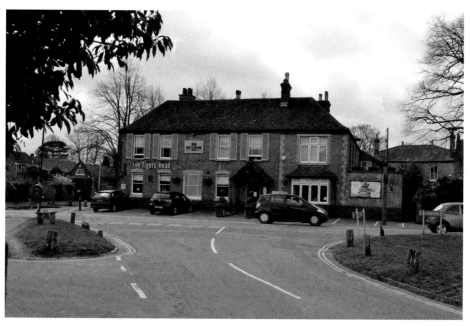

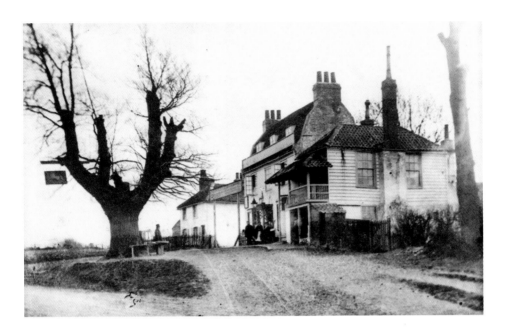

The White Horse, *c.* 1890

At the top of Red Hill, with its view towards the London skyscrapers at Canary Wharf, is the Lounge, originally the site of the White Horse, a picturesque old inn of Kentish design with weatherboarding and dormer windows. The name board used to hang on a huge elm tree, which took the brunt of the south-west gales as they hit the crest of the hill. The old coaching inn was demolished in 1899, when the top of the hill was actually lowered to fill in the duck pond of Red Hill farm (now the site of Chislehurst Library). This location has seen many reincarnations of its hostelry since its early Georgian days. The pub was relatively recently known as the Penny Farthing. Nowadays, it hosts live entertainment with resident singers and has playrooms for younger children open during the day.

Roads

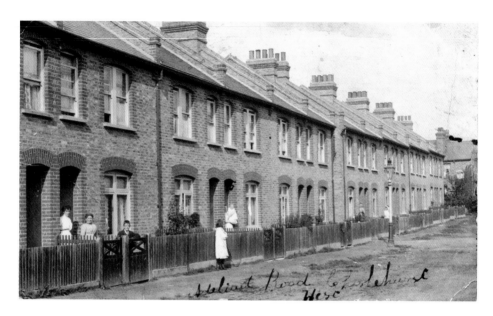

Adelaide Road

This narrow Victorian street does not appear on any census before 1901. It is therefore unlikely that it is named after the consort of King William VI, unlike the Australian city of that name. As it is adjacent to Edward and Alexander Roads, one wonders if the names are those of the developer. Part of the district of Prickend in Chislehurst West, the road appears to be of traditional cottages, built for workers' families, people working in the mineral waters factory nearby, or on the land along Belmont Grove. Today, the street is no longer the safe haven in which children played, as it is lined with cars.

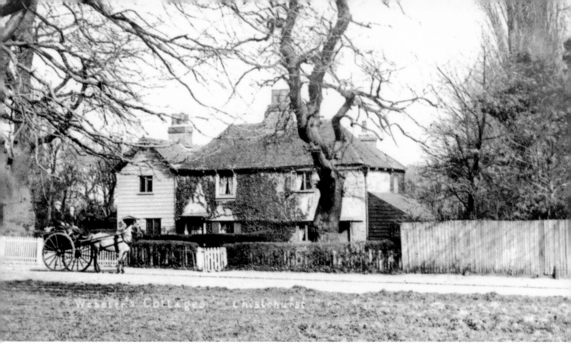

Ashfield Lane

Ashfield Lane skirts the northern edge of Chislehurst Commons, and on the junction with Kemnal Road was Webster's Pond, now filled in. Arthur Battle, in his book, *Edwardian Chislehurst*, recounts how he used to drive his horse into Webster's Pond to cool off during his baker's delivery round. Webster's Cottages along with Oak Cottage are the oldest houses in Ashfield Lane. Webster's Cottages were created from a house occupied by a Mr Ringer, a suspected smuggler. His fine celery beds were reputed to be the hiding place for his contraband gin!

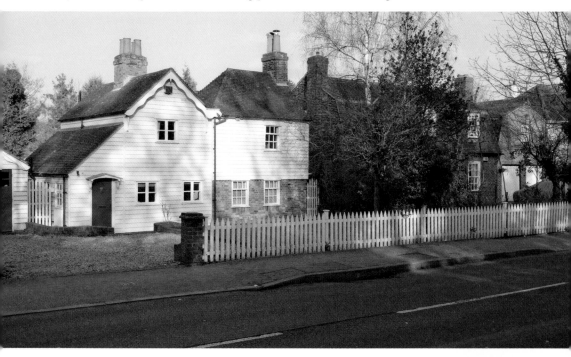

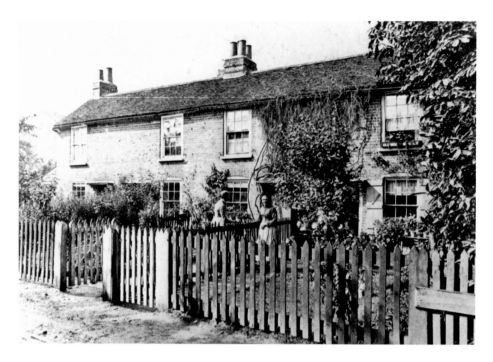

Crown Lane

Crown Lane and Morley Road converge onto Watts Lane on the edge of the Common. Morley Road is named after Charles Morley, a builder and one time resident of Coopers, who erected the cottages in that road. The cottages pictured here in Crown Lane, a narrow, quiet Victorian street, were typical of the homes of gardeners, coachmen and grooms who worked in the 'big' houses in the area. Unfortunately, a flying bomb in the Second World War put paid to these charming cottages and sympathetic modern housing has taken their place. The road is still narrow but jammed with parked cars; one navigates with some trepidation!

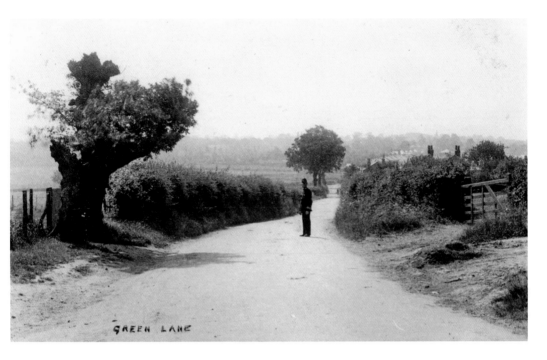

GREEN LANE

Green Lane, c. 1905

If ever a picture showed complete change, then this is probably it: from the once wide open fields where vegetables such as artichokes were cultivated, to what is now a suburban scene. In 1931, new roads were created off Green Lane, formerly known as Sweeps Hill. Housing has claimed the open space, and Green Lane is now a commuter route from the village to the A20 and beyond. Even the role of the police has changed; the old helmet is a thing of the past and today, community officers patrol in twos.

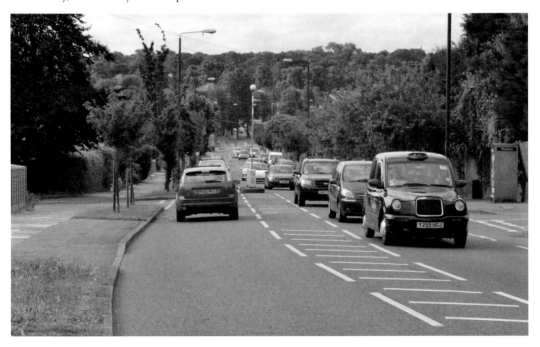

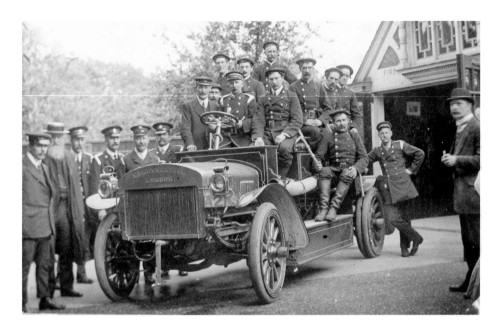

Fire Station, Hawkwood Lane, *c.* 1912

Hawkwood Lane is one of the oldest roads in the village. The old fire station, manned by a volunteer force, is now the depot for the Trustees of the Chislehurst and St Paul's Cray Commons. Where once the old fire engines were polished and readied for action, it now houses mowers and trucks for the keepers. The horses that pulled the fire truck were stabled behind the Tiger's Head. Hawkwood Lane still functioned as a fire station until the time of the Greater London Government reorganisation. The Kent County Council Fire Service transferred the building to the GLC in 1965, and the London Borough of Bromley Education Department used the building to house the mobile library vehicle. The trustees formally took over the building on 1 April 1966, moving from their offices at No. 8 Royal Parade.

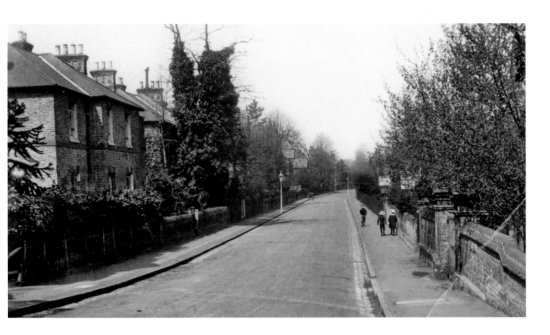

Lower Camden, *c.* 1890

This road represents the outer edge of the original Camden Park Estate, developed by Nathaniel Strode in the 1870s. It is a low-lying road, between the railway to the south and the River Kyd to the north. With no gradient to speak of, it provides a relatively straightforward route, beloved of delivery vehicles and, nowadays, a route to the station. Few of the original houses remain, though the pairs of older semis towards the junction with Lubbock Road are reputed to have been the homes of several of the entourage of Napoleon III.

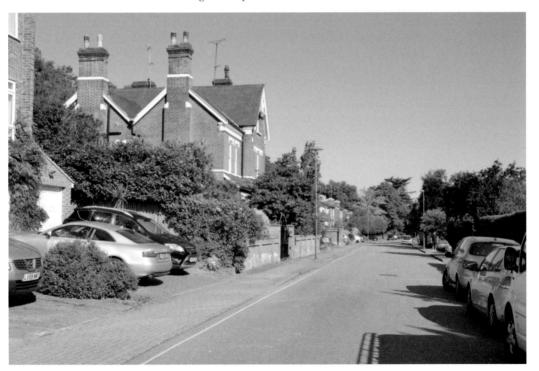

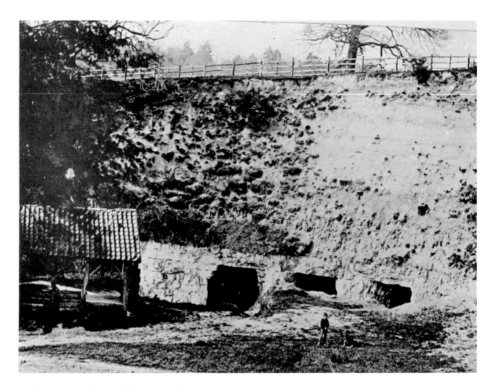

Lubbock Road Limekilns, c. 1860

At the lower end of Lubbock Road, an area marked on old maps as Deans Bottom, behind what used to be the stables of William Willett, the chalk face of an old mine can just be seen. The oldest maps of the area note 'British Pottery and Ancient Remains found here'. The mine has long since been closed, but the story goes that the chalk mined was particularly white and used to colour bricks and mortar; so good in fact, it was used by Sir Christopher Wren on St Paul's Cathedral. After serious floods in 1968, water filled the area to some 10 feet in parts and a landslip buried the entrance. It would take a keen eye to spot the past now and the house on the site enjoys a very different environment to its former industrial archaeology.

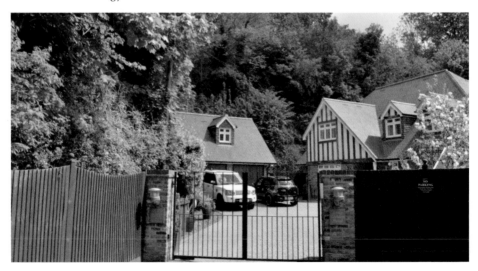

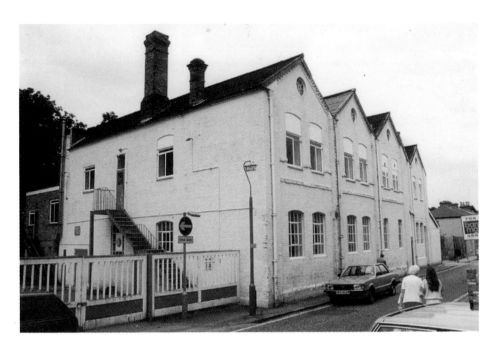

Chislehurst Mineral Waters, Park Road, c. 1980

There were many springs in Chislehurst producing good quality water, with the earliest reference to the commercial production of mineral water featuring in *Strong's Directory 1879*. By 1883, the Chislehurst Mineral and Aerated Water Works were described as the sole manufacturers of the 'celebrated non-intoxicating Chislehurst Ginger Ale'. The factory developed on the north-west side of Park Road. It was a large, two-storey building, with three gables fronting the street, a rear shed and side access for horse-drawn carts. Advertisements from 1887 include references to the 'important Orange Champagne'! In 1952, the company was bought out by Whitbread & Co., and the Park Road site became a depot. The buildings were demolished in 1988 to make way for Park Mews, a small housing development. Run by local father and son Moses and Harry Line, nothing remains of the old factory today, but it is not unusual to find remains of the charming old glass bottles. One such bottle, embossed 'HL' (Harry Line) was recently unearthed intact in Chislehurst Recreation Ground. Not exactly a rare antique, but a collectable piece of local heritage all the same.

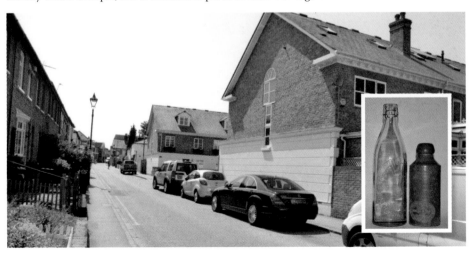

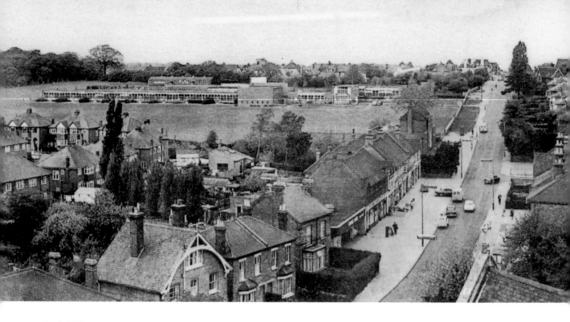

Red Hill, c. 1955

This is an upside-down hill! In 1899, the hill was lowered from the summit and the spoil taken to fill up the pond on the former Red Hill Farm, now the site of the library in the centre of the contemporary picture. Red Hill School was opened in the 1950s to accommodate the rapidly expanding primary age group in Chislehurst. This group continues to grow to this day and the site now includes a day nursery for the under-fives. Red Hill has been widened by reducing the width of the pedestrian area to allow for the ever-increasing flow of traffic. Modern developments include the arrival of supermarket shopping, a day centre for older residents and a doubling of the space above the shops.

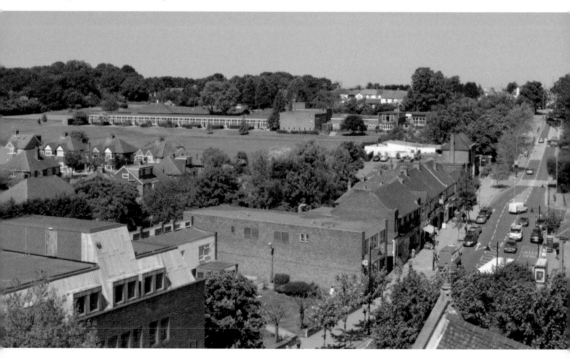

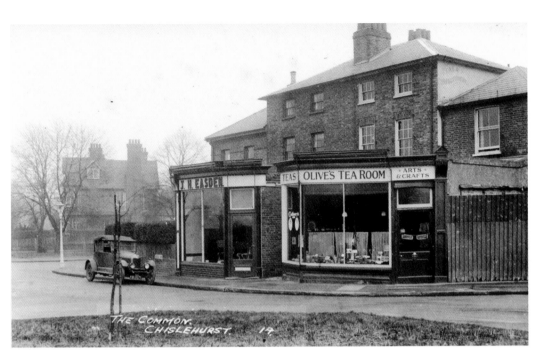

Royal Parade Corner

The shops at the end of Royal Parade and Church Row were charming small enterprises, almost standing guard at the junction. Now the established businesses watch the comings and goings of schoolchildren heading across the common to St Nicholas Church of England Primary School and Coopers Technology College. The commanding view also takes in traffic jams at the busy crossroads and the poignant scene of the war memorial, which, of course, was never even dreamt of when these shops were first in operation.

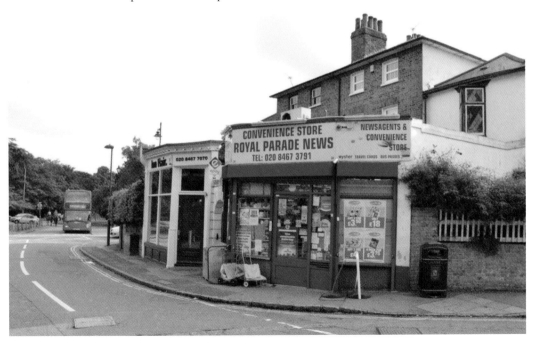

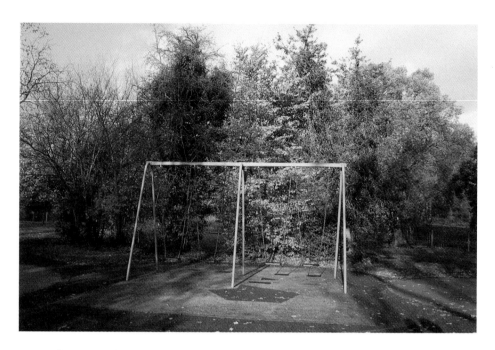

Recreation Ground, Walden Road, c. 2000

The recreation ground, with its broken swings, was an unloved corner of Chislehurst, providing an unexciting area for local children to play safely. Now the playground has been revitalised by the Friends of Chislehurst Recreation Ground. Jointly funded by the London Borough of Bromley and the Chislehurst Society, it is now an appealing and fun place to visit. The children of Red Hill School were involved in the design, which includes a zip wire, climbing frames, monkey bars for older children and a toddler corner. Plans are well advanced for disabled access and the friends plan regular events and activities.

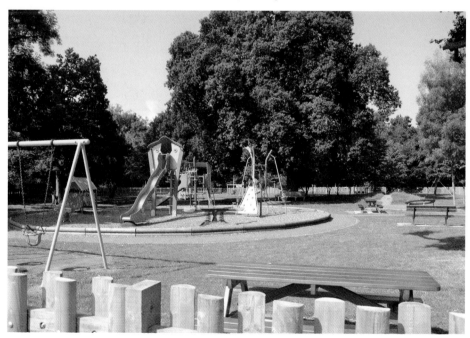

Schools

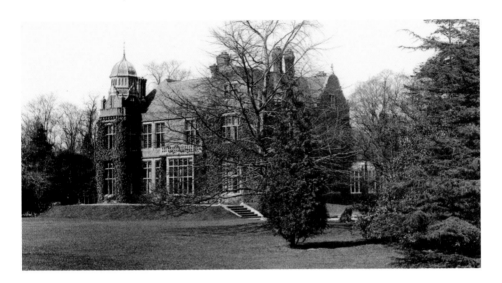

Babington House, c. 1910

Built in 1879 on a 22-acre site for dry goods merchant John Comer Scott, this house was originally known as Elmstead Grange. The Jacobean-style house was the home of Kenneth and Ethel Bilborough from 1904 to 1940. Kenneth was the third son of Arthur Bilborough, founder of the shipping company that still bears his name. In 1959, the Grange became Babington House School, which had been founded in Eltham in 1887. The school takes its name from Thomas Babington Macauley, a great Victorian writer and politician and friend of the school's founder, Madame Roussell, a distinguished Belgian lady interested in fostering the arts for 'young ladies and small boys'. After a further period of being a school just for girls, the twenty-first century has seen a return to co-education. The ivy-clad towers are now stripped bare in order to better maintain the brickwork, and the school enters a new era under a change of headship.

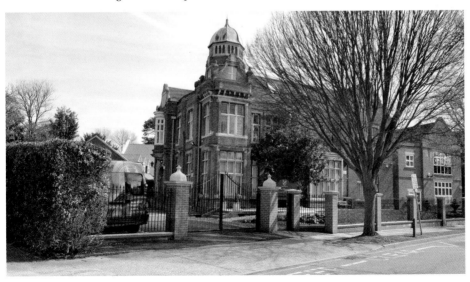

Bullers Wood, c. 1860

Named after an ancient forest, the original Bullers Wood House was built in the 1860s and was owned by the Sanderson family from the 1870s. Sanderson, who had made his money sheep farming in Australia, employed local architect Ernest Newton to extend the house in 1889. The result is an Arts and Crafts-style house, which sits on an elevated terrace overlooking woodland. Morris & Co. were employed to decorate the interior. It is said that William Morris himself contributed the beautiful library wallpaper and hand-painted ceiling, which remain in situ. A carpet, named Bullers Wood by Morris, is on display in the Victoria and Albert Museum. The house became the Royal School of Church Music in 1930, educating boys only. In 1939, the local authority maintained the school as Bullers Wood School for Girls, with their distinctive black-watch uniform. As the march of educational progress continues, boys have joined the sixth form and business attire is the order of the day.

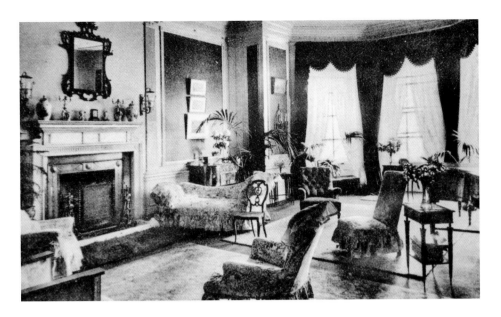

Coopers, 1908

Coopers Mansion House is a fine Georgian house, built by London solicitor Francis Cooper in the eighteenth century. Always a home for notables, knights, judges, MPs and distinguished visitors, including Gladstone, it fell vacant in 1906 after the loss of fortune of the Firbank family. Ronald Firbank was a relatively famous Aesthetic author of the 1920s. The clothes of his sister Heather, donated to the Victoria and Albert Museum, inspired the costumes for the television series *Downton Abbey*. Coopers opened in 1908 as Tudor Hall Girls School, which remained in Chislehurst until it was evacuated in 1939. The school continues in Berkshire to this day. Today, Coopers is an Academy and the Grade II listed mansion has been restored sympathetically. The results are spectacular, with the restoration of the Adam-style fireplaces and ceilings, the sixth-formers have a lot to care for and respect.

Edgebury, *c. 1960*

Chislehurst Secondary School for Boys, later Edgebury School for Boys, had a chequered career, changing status as the whims of government policy played out. Built in the 1940s, alongside local lads, it provided education to the refugee children newly arrived in Chislehurst from war-torn Europe and the bombed-out East End. Edgebury was a large school with its own playing field, described as a battlefield by some! The wife of Kenneth Clarke MP was the daughter of Mr Edwards, an Edgebury teacher. Some local residents will recall his nickname! There was a brief time when the school was co-educational, but it finally closed in 1976. The school was bulldozed and several new homes now occupy the site.

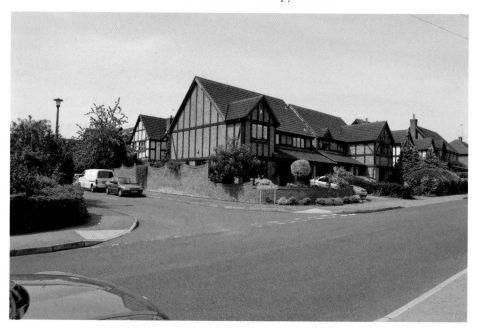

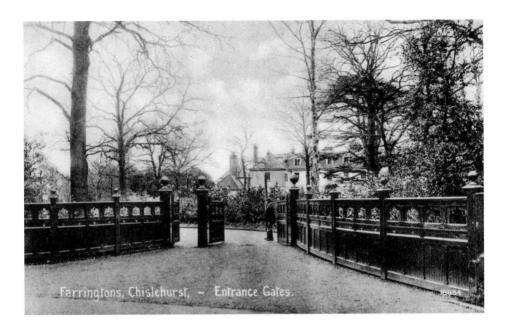

Farringtons, Chislehurst, – Entrance Gates.

Farringtons, c. 1925

Originally, a seventeenth-century mansion stood on this site. Before it fell into disrepair, the house had been home to three generations of the Farrington family, from whom the school takes its name. The land for the school was bought in 1908 to create a Methodist girls' school, a sister school to the very successful Leys School for boys in Cambridge. The first governor of the school when it opened in 1911 was Sir George Chubb, later Lord Hayter, the grandson of the founder of the Chubb & Sons Lock & Safe Co. Not much has changed today. The grounds are less formal and the grand entrance gates have given way to wooden fencing. The chapel is now home to the charismatic Ichthus church at weekends.

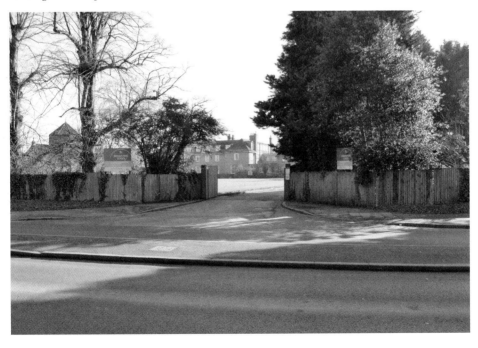

Mead Road

The school in Mead Road, originally called Pennthorpe, was designed by Ernest George around 1890. It is clearly shown on the 1895 map of Chislehurst West, standing proud as one of only six houses in the road. In 1891, it was a boarding school for girls. The school continues to thrive today as Mead Road, a one form entry infant school. How different primary education looks today! Gone are the serried rows of desks, in comes light, colour and activity and learning achieved through play.

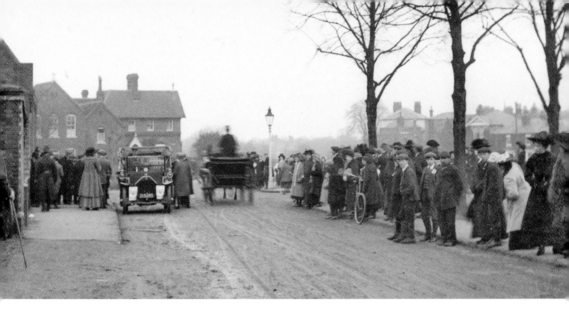

St Nicholas School/St Michael's Orphanage, 1910

It has long been tradition for schools and public buildings to be used as polling stations for local and general elections. This classic photograph, outside St Nicholas School in Chislehurst, was taken during the 1910 general election. How many of the women would have been eligible to vote? It wasn't until 1918 that women could vote, and even then it was only for those over thirty who met the minimum property qualification. The school itself was established as the National School in 1835 'for the education of the poor in the principles of the established church'. Nowadays, it is more properly described as a 'vibrant and caring family centred school in a Christian community'. The photographs also show the former St Michael's orphanage, now occupied as private houses.

Willow Grove School, *c.* 1910

This was the Wesleyan School in what is now Furzefield Close. Until its main building was ready, for a couple of years from 1875, the school was housed in the schoolmaster's house further along Willow Grove, in a house now called the Stead. The school became a local authority maintained establishment in the 1930s and the schoolmaster's house became a private residence. In the 1950s, Oliver Philpot, who escaped from a German prisoner-of-war camp and whose story became the book and film *The Wooden Horse,* was a lodger. The school closed in the 1960s and was finally demolished in March 1974.

Events

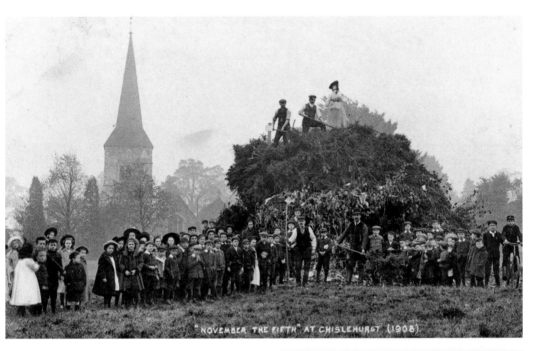

"NOVEMBER THE FIFTH" AT CHISLEHURST (1908)

Bonfire Night, 1908

Guy Fawkes Day was always a great occasion. Each year, the Commons keepers would cut large quantities of gorse and the boys of the village would drag it to three recognised venues: the Cockpit, the hollow next to Prickend Pond and Mill Place. Large crowds attended and some familiar faces, including this suffragette, were burned at the stake. However, hooliganism became serious. Traffic was endangered and on the final occasion the fire brigade was called to extinguish the fire but, before they could do so, the hoses were cut. At the request of the police, the keepers had to discontinue the event. Now, the Rotary Club has risen to the challenge of providing a spectacular and safe event, which is enjoyed on the recreation ground every November, raising money for charity in the process. However, one tradition remains: Guy is still burned at the stake!

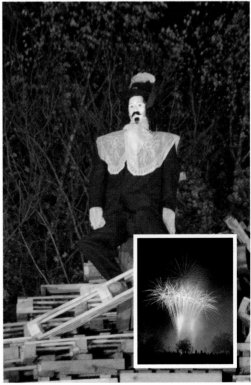

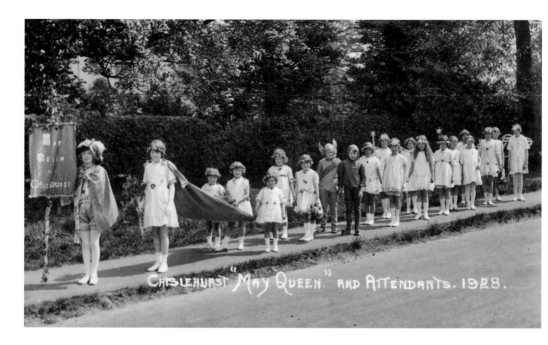

CHISLEHURST "MAY QUEEN" AND ATTENDANTS. 1928.

May Queen

The first Saturday of May 1923 saw the first of the present series of crowning May Queens. With the exception of 1943, when one queen reigned for two years, there has been no break in this popular annual ceremony. This long-standing tradition continues to this day, with girls mastering the complicated routines of maypole dancing. The annual ceremony attracts hundreds of people to follow the parade and see the crowning. The May Queen presents prizes for entrants in a fancy dress competition and now uses a microphone to be heard, protected by wardens in high visibility jackets rather than her erstwhile pages.

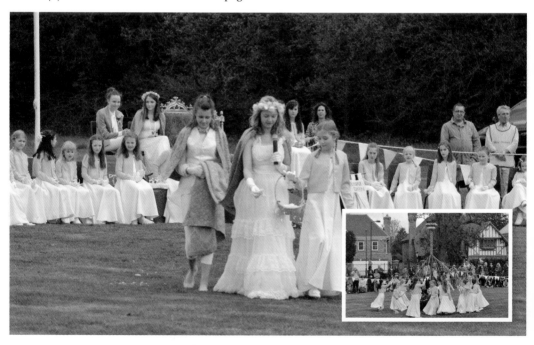

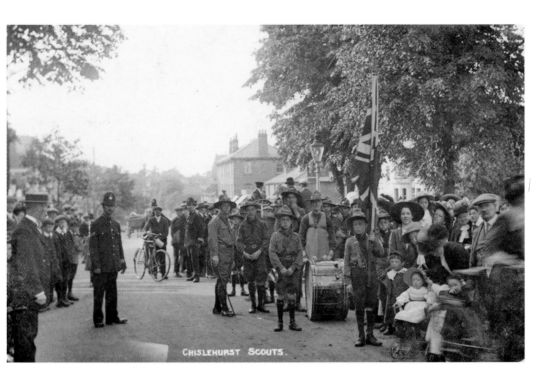

CHISLEHURST SCOUTS.

Parades, *c.* 1911

Important occasions in the life of the village are often accompanied by a parade. The High Street is the usual venue for the parade, culminating in a gathering by the pond or on the Commons. In these scenes, scouts gather outside the Queen's Head for the Coronation of King George V. In the picture from a century later, young people of both sexes are represented and protected by their high-visibility minders, rather than the police.

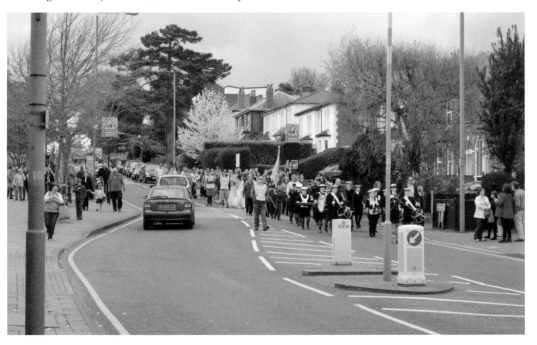

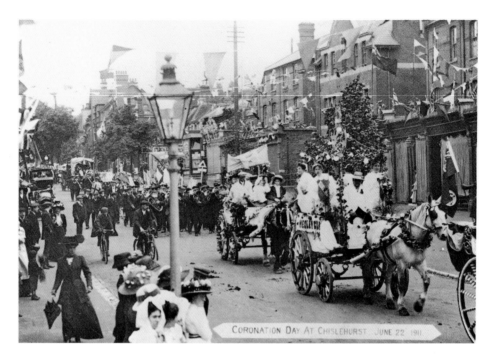

CORONATION DAY AT CHISLEHURST JUNE 22 1911

Royal Events, 1911 and 2012

Chislehurst celebrates royal occasions in style. The royal visit by Queen Elizabeth I is commemorated by the village sign on Royal Parade. Visits by Queen Victoria during the sojourn of the French Imperial family at Camden Place, are commemorated with emblems on the walls, in both St Nicholas and Christ Church. The Coronation of King George V was celebrated with the parade pictured here. The 2013 Diamond Jubilee of Queen Elizabeth II saw a huge picnic on the Commons: a very colourful event in an otherwise grey summer.

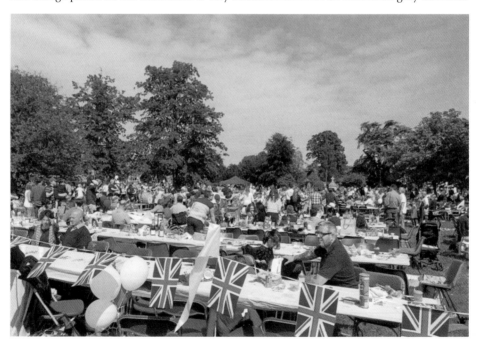

Diamond Jubilees, 1897 and 2012

The Diamond Jubilee of Queen Victoria in 1897 was marked by this magnificent stained-glass window in Christ Church, Lubbock Road. High up in the roundels can be read 'Victoria Regina, Sixty Years Queen'; the dates 1837 and 1897 are at the base of the window. The Jubilee was also marked by planting a lime tree on Royal Parade. This is something of a tradition: to celebrate our current monarch's Diamond Jubilee, an oak was planted by the Mayor of Bromley. The lime tree in the background is now a sturdy specimen with over 100 years of growth.

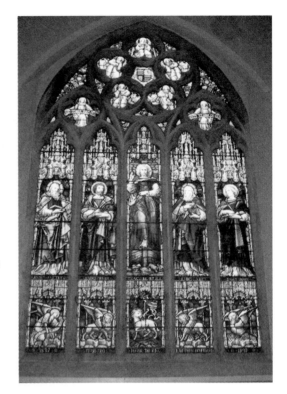

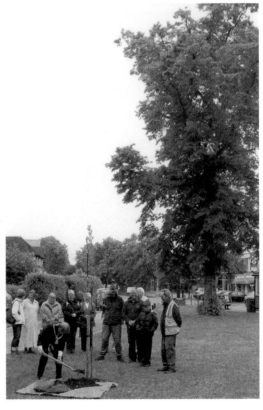

Shops

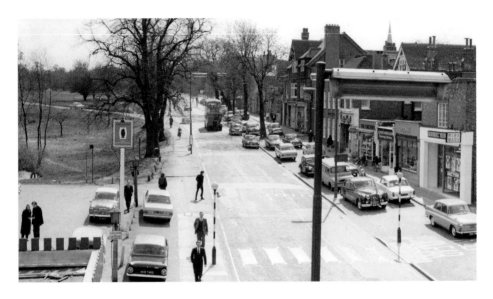

High Street, _c._ 1969

From the late 1890s, the village High Street has been a hive of activity. Always a street of busy individual retailers, it is more the nature of the businesses that has changed, rather than the shape of the High Street. It still retains its tree-lined charm, despite the change from horse and carriage to motor vehicles, traffic lights and parking meters. The early twentieth-century scene was one of grocers, butchers, fishmongers and greengrocers; now the theme is personal services, such as haircare, gifts and coffee shops, with a variety of different restaurants and a number of estate agents. Cars have been a major influence on the changes to the High Street; where cars were once new-fangled and a rarity, now they dominate our lives. Initially, parking on the High Street was linear, compared to the parallel in/out spaces of today.

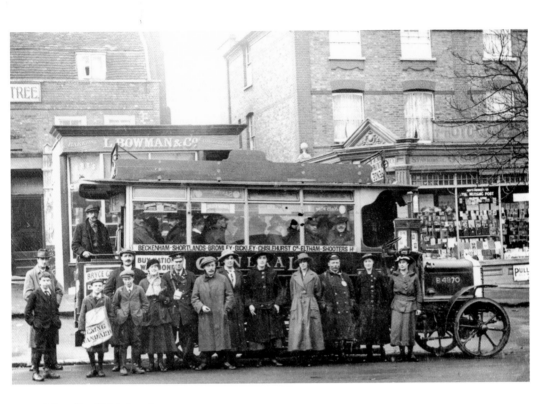

A Bus for Chislehurst, c. 1920

Change became automated in terms of public transport on Sunday 5 April 1914, when the first motor omnibus arrived and service 159 began from Chalk Farm to the Bulls Head, on Sundays only. In June of that year, the 151 was added from the Bull to Woolwich. These services were withdrawn during the war, but resumed when peace returned. Nowadays, we are used to frequent services for our convenience, which we all take for granted. Imagine having to wait for your bus just once a week!

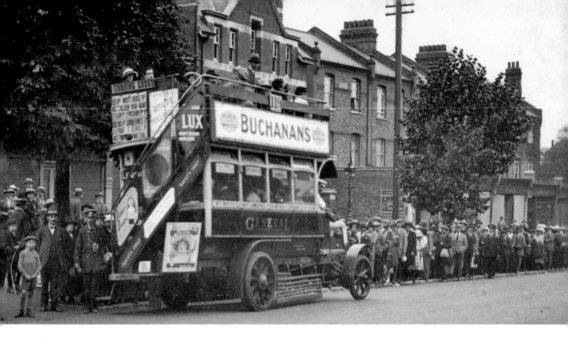

High Street Bus Queues

Sir John Lubbock, one-time resident of Chislehurst, created bank holidays in 1871 by an Act of Parliament. Chislehurst became a very popular destination on these days off, as this scene bears witness. People came from the heart of London to enjoy the open spaces of the Commons and many tea rooms in the village provided refreshments. The High Street was mobbed by queues waiting for the bus to return home. Today, the High Street is open for business whether it is a bank holiday or not, and the car seems to be the prevalent mode of transport.

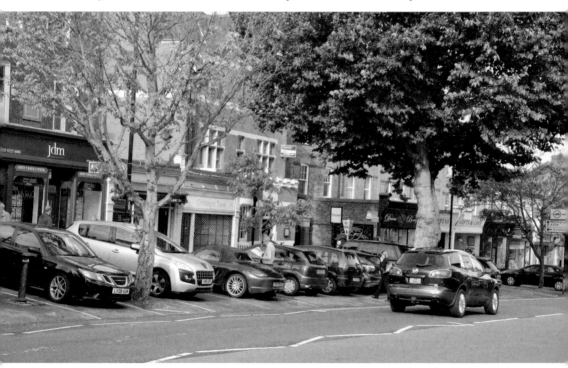

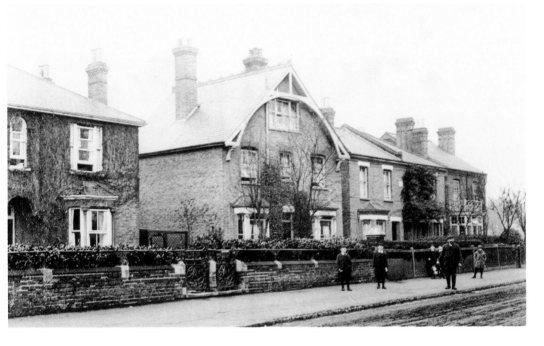

Burlington Lodge, c. 1910

Burlington Lodge was in the centre of a row of Victorian houses, now the site of Sainsbury's supermarket. The name Burlington is taken from a South African town of the same name, where local investor Mr Squires had invested money in the nearby gold fields. St Mary Hall, behind Burlington Lodge, was built in 1877 and housed many local functions; these included an exhibition at which Empress Eugenie exhibited some of her needlework. The Annunciation School was behind the hall, but succumbed to massive bomb damage in 1944. The site remained semi-derelict until the supermarket was built in 1972.

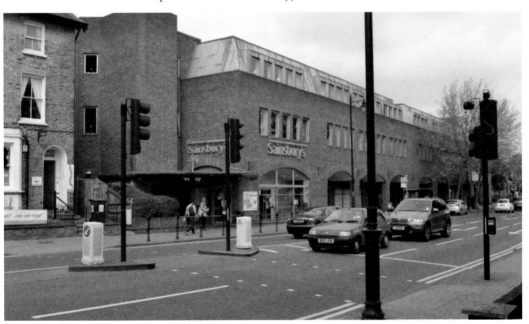

British Restaurant, 1943

Chislehurst had its own purpose-built British Restaurant during the Second World War. These restaurants were run by the London County Council to provide a decent meal at a low cost. A typical three-course meal might have included soup, braised tongue and a pudding, all for 9d. It was a remarkably successful social experiment; by 1943, there were 200 establishments across London, providing relatively cheap meals in a reasonably bright and comfortable environment. The restaurant in Chislehurst, with its corrugated roof and narrow vertical windows, stood next to the library on Red Hill. Parties were held at the restaurant for VE Day, but by 1958 it had closed. Now, the perimeter of the library car park provides the bright and comfortable environment of Red Hill children's nursery.

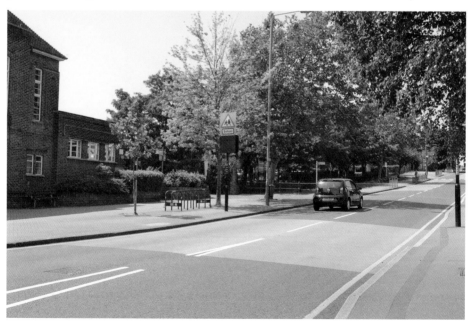

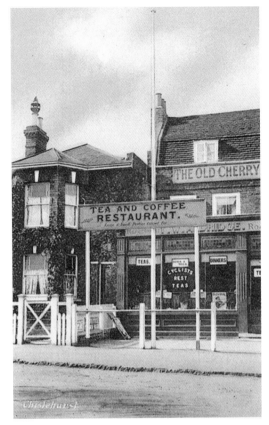

Cherry Tree Café, *c.* 1910

Chislehurst High Street has many and varied watering holes, and it is not difficult to find a pleasant café in which to enjoy a cup of tea. The Old Cherry Tree was one of the original places in which to partake of refreshment. Serving tea and coffee to travellers and coachmen, it catered at weekends for cycling parties. As is usual for an ever-changing High Street, the Old Cherry Tree has had many guises over the years, from a ladies and gents hairdresser to its current use as a 'jewellers' shop.

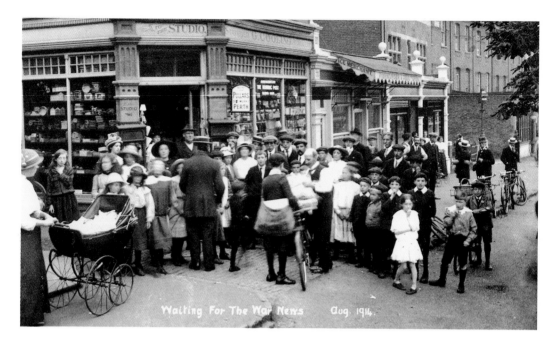

Waiting For The War News Aug. 1914.

Cooling's

The Cooling family business, established in 1888 on Chislehurst High Street, was a stationer's and newsagent's, which diversified into photography. George and Elizabeth Cooling had ten children and ran their business at No. 93. At No. 41 High Street, George Cooling's brother ran a fishmonger's business. The Cooling name today is probably more synonymous with gardening and the garden centre enterprise in Knockholt; this started out as 3 acres of land behind Camden Grove, behind Chislehurst High Street. The premises from which Coolings plied their paper trade remains in the same line of business today – Paper Lane sells cards and stationery, just like George Cooling before them.

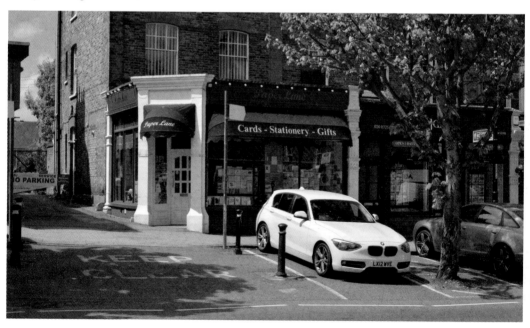

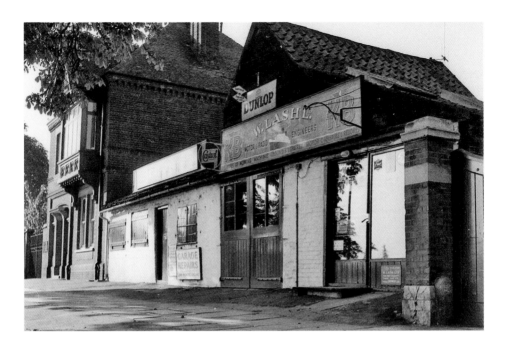

Lash's Forge, *c.* 1930

Commemorated by a plaque on the wall of the existing building, this ancient forge, owned by the Blackney family, built and repaired coaches from 1792. The forge originally constructed wheels and a blacksmith fitted horseshoes. From the early twentieth century, three generations of the Lash family worked there making motor car bodies. In 1960, the old building was demolished to make way for new commercial industry in the shape of Barclays Bank and one of the many estate agents on Chislehurst High Street. There is a memorial bench to Mr and Mrs A. E. Lash on the Common, opposite the old site.

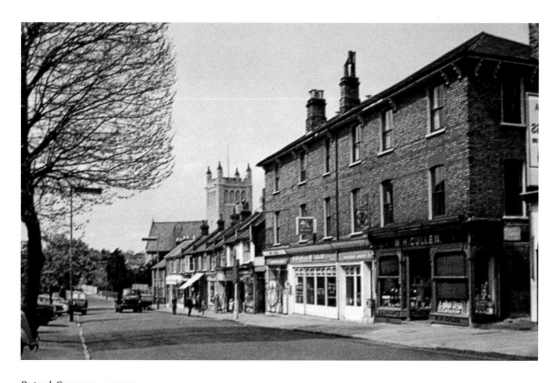

Petrol Garage, c. 1950

Chislehurst even had a petrol garage on the High Street. Cars would pull up to the kerbside to Swan & Willis, where there were two pumps. Customers were served by an attendant – none of the self-service business of the twenty-first century! There were other service stations on Royal Parade and Mottingham, but today Chislehurst drivers have to head to the A222 for their petrol.

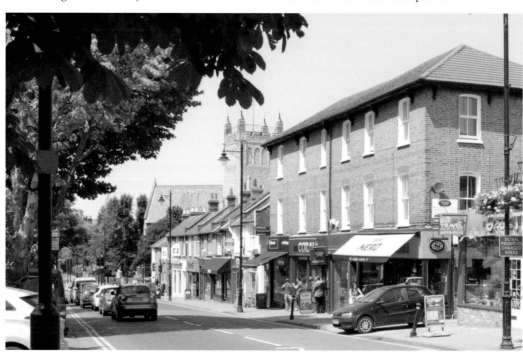

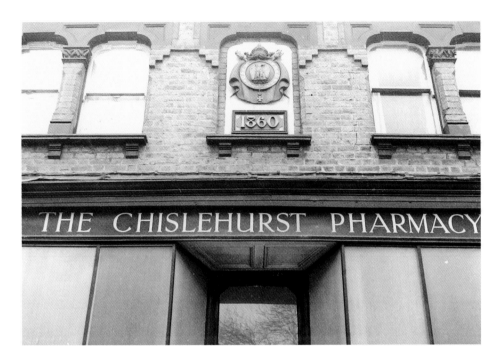

Pharmacy on Royal Parade, *c.* 1920

Above the antique shop, a long-standing business on Royal Parade, is the emblem of the French Imperial Arms, dated 1860; it was added much later than its date would suggest. The Chislehurst Pharmacy, which was originally on this site on Royal Parade, is described in detail in *Edwardian Chislehurst* by Arthur Battle. First known as Wing, Aplin & Co., it became Prebble & Bone, with branches in the High Street and Lower Camden. Battle describes the coloured glass jars in the shop window and the dispensing of camphorated oil and Parrishes chemical food for children. Chemists thrive on the High Street today, and a new pharmacy has recently opened at Lower Camden.

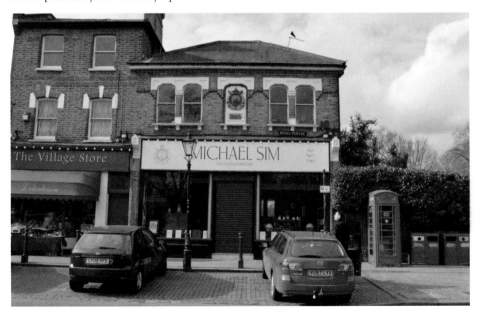

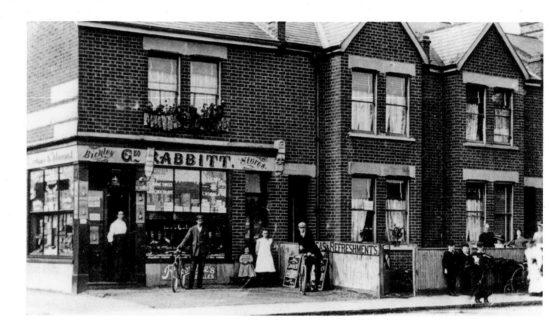

Rabbitt's Stores, c. 1900

This delightful late-Victorian image shows the way we used to shop. Rabbitt's, at the corner of Edward Road and Green Lane, started out as a confectioner's, selling chocolate, sweets and refreshments. This image shows an advertisement for Camden Mineral Waters – possibly an adjunct of the nearby Chislehurst Mineral Waters factory, or a short-lived entity bottling water from the Camden Park Estate. The store was patently appreciated by the local children. The business survived as a grocer's shop well into the sixties. Some may remember it as the Bounty Box in its last incarnation, being one of the few stores open on a Sunday. However, the arrival of the nearby supermarket put an end to its independent success and, after being closed for many a year, it was finally converted into flats in January 2012.